MW01491671

IMAGES
of America

ROUND ROCK

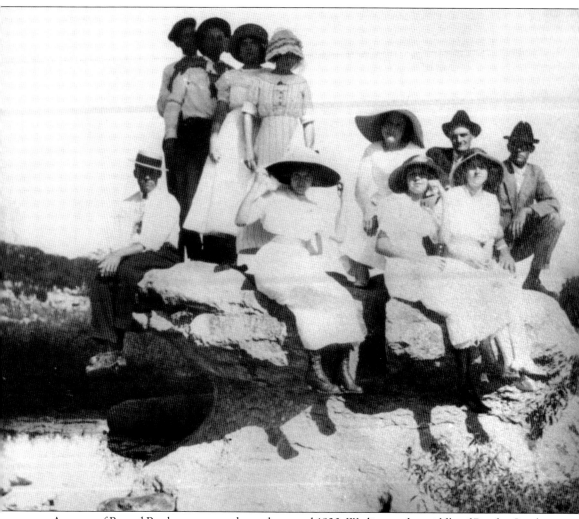

A group of Round Rockers pose on the rock around 1920. Wading to the middle of Brushy Creek to climb on the rock has long been a popular tradition. Posing from left to right are (seated) Robert Egger, Ida Canova, Nettie Bradley, and Elizabeth Landrum; (kneeling at right) Louise Aten, Ivan Aten, and Cecil Cochran; (standing) Cecil Thorp, Jewell Cluck, Floy Wright, and LaNella Chambers. (Courtesy Martin Parker.)

ON THE COVER: This early-1880s photograph is one of the oldest known views of Round Rock. To the left is the blacksmith shop of Richard Tatsch, who also partnered with Carl Steinberth. To the right is W. H. D. Carrington's building, with a hardware and general store downstairs and a saddlery on the second floor. C. O. Kelley, who founded a dry cleaners in 1942 in a building under the water tower, moved Kelley's Cleaners to Carrington's building in 1957. (Courtesy Martin Parker.)

IMAGES
of America

ROUND ROCK

Bob Brinkman

ARCADIA
PUBLISHING

Published by Arcadia Publishing
Charleston, South Carolina

Printed in the United States of America

Library of Congress Catalog Card Number: 2008921582

For all general information contact Arcadia Publishing at:
Telephone 843-853-2070
Fax 843-853-0044
E-mail sales@arcadiapublishing.com
For customer service and orders:
Toll-Free 1-888-313-2665

Visit us on the Internet at www.arcadiapublishing.com

To Steph, my life partner

CONTENTS

ACKNOWLEDGMENTS

Tell us what the former things were, so that we may consider them and know their final outcome.

—Isaiah 41:22

Compiling this pictorial history of Round Rock has been most enjoyable. Hopefully you will find our town's history interesting and inspiring enough to make you want to learn more about it. I am indebted to the good citizens of Round Rock who have spent generations building a community and also to those along the way who have taken the time and effort to record the history for posterity.

A most heartfelt thank-you goes out to Martin Parker, native of Merrilltown, Round Rock High School class of 1944, longtime postmaster, author, and historian. Martin most generously offered me the use of his collection of historic photographs, which have greatly enhanced my efforts. Thank you for your kindness and your friendship.

Thank you to the individuals and organizations who shared images and ideas for this book, especially the City of Round Rock, Round Rock Chamber of Commerce, Round Rock High School, Round Rock Independent School District, *Round Rock Leader*, Texas Department of Transportation, and Texas Historical Commission. Ray Amaro, Mary Cahill, Anne Cook, Marcial Guajardo, Marcia Hilsabeck, Joelle Jordan, Susan Komandosky, Vicki Moreno, John Reed, Anne Shelton, Brad Stutzman, and Irene Varan have been most generous with their time and resources.

Thank you also to my folks, Bill and Lin Brinkman, and to my whole family for their help and support.

INTRODUCTION

Round Rock is one of the oldest communities in Central Texas, with archeological and anthropological evidence of thousands of years of occupation in the area. Permanent settlement dates to the late 1830s. Kenney's Fort along Brushy Creek was an early landmark and was the site of two noteworthy episodes of Republic of Texas history: the beginning of the Santa Fe Expedition of 1841 and the end of the Archives War of 1842. Settlement consolidated along Brushy Creek near a crossing of the Central Military Road leading north from the new national capital of Austin. This path, adjacent to a round rock of natural limestone in the creekbed, became a stagecoach route that passed through a village called Brushy Creek, which in 1854 changed its name to Round Rock.

The community and Williamson County were pro-Union in the days leading up to the Civil War and were among the few areas of Texas to vote against secession. After the war, cattle drives from South and Central Texas passed through the town on the way to markets in Kansas and the West. Round Rock also became a leading educational center, with the establishment of Round Rock Academy and Greenwood Masonic Institute in the 1860s and Round Rock College and Round Rock Institute in the 1880s.

Leading immigration groups to the area in the 19th century included families from Swedish, German, and Czech lands, as well as large numbers of immigrants from Tennessee, Arkansas, and Illinois. African American and Mexican American groups also increased in population in the late 1800s. The arrival of the International and Great Northern Railroad in 1876 energized the local economy and made a boomtown of Round Rock, which was the end of the rail line for over a year, serving as the closest shipping point for 10 counties to the west. Briefly, Round Rock had six hotels to Austin's five. This connection to large Eastern cities by rail also brought new citizens from varied backgrounds.

Local businesses included limestone quarries and lime processing plants. William J. Walsh's Round Rock White Lime Company began in 1896 and was a major employer in the city for 75 years. Other agricultural industries included the Round Rock Broom Factory (begun in 1876) and the Round Rock Cheese Factory, which opened in 1928. Cotton was the main agricultural crop from the 1880s until the 1920s. At the dawn of the 20th century, Williamson County was one of the top producing cotton counties in Texas and even No. 1 in the United States during a couple of fall harvests.

Other notable developments in Round Rock included Trinity Lutheran College (1906–1929), which later was an orphanage and retirement home and is still operating in the community; Lone Star Bakery (established 1926), maker of famous Round Rock Donuts; the arrival of U.S. Highway 81 (1934) and Interstate 35 (1959); heavy industries including Westinghouse (1972); and explosive growth in the last generation that has seen the population increase from under 3,000 (1970) to 12,000 (1980) to 35,000 (1990) to an estimated 92,000 today, with Dell Computers and other major employers bringing rapid change to the city.

Round Rock claims notable lawmen, educators, writers, military veterans, cattlemen and cattlewomen, philanthropists, ministers, businesspeople, and athletes. Just as significantly, the community has a long tradition of unsung heroes who have toiled just as hard to improve conditions for their families and their friends. Taken together, all these contributions have combined to create the unique place called Round Rock.

One

FRIENDS AND NEIGHBORS

Some of Round Rock's most celebrated native sons and daughters began life here but moved away before achieving their most notable accomplishments. Ira Aten made a name for himself as a Texas Ranger quelling vigilante justice in Fort Bend and San Saba Counties, securing law and order on the frontier as foreman of the XIT Ranch in the Texas panhandle, and settling the town of El Centro in California's Imperial Valley. Juanita Craft attended Hopewell School, Round Rock's separate school for African American children, before moving on to Dallas and becoming a leading advocate of civil rights, registering thousands of women to vote.

Others were famous in their time before they moved here late in life. Judge Cadwell Walton Raines was the Texas state librarian and a founder of the Texas State Historical Association, helping preserve precious documents of Texas history at the dawn of the 20th century. His final years were spent in Round Rock, and he is buried at the Round Rock Cemetery. Renowned fiddler Johnny Gimble already achieved fame as one of Bob Wills's Texas Playboys and in the decades of music that followed before he lived for many years in Round Rock. While he was here, he helped put the town on the musical map with the Texas Bluegrass Festival.

But the people who deserve the greatest commemoration as citizens of Round Rock are those who have lived and died and dreamed and laughed and cried and grown along with the community as time has marched forward. Some were here for a short time, while others have been icons for generations of family and friends. Individuals like Ellen Blair Davis and Beulah Mercer have each spent their whole lives in Round Rock, full lives that have spanned more than 100 years. Their lives are the threads that comprise the rich tapestry of the city.

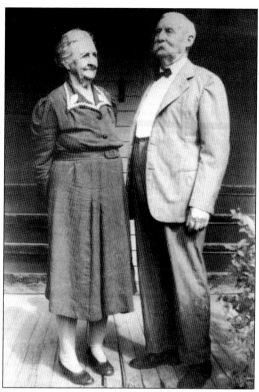

Josie (McCormick) and Frank Aten were married in 1886. Frank came with his family from Illinois in 1876 at the age of 16, while Virginia-native Josie and her family moved here in 1882 when she was 14. Frank was a justice of the peace, a postmaster for 10 years, and fa ounder and later president of the Old Settlers Association. He was also known as an expert beekeeper. Josie and Frank had six children, and Frank died in 1960 at the age of 99. (Courtesy Martin Parker.)

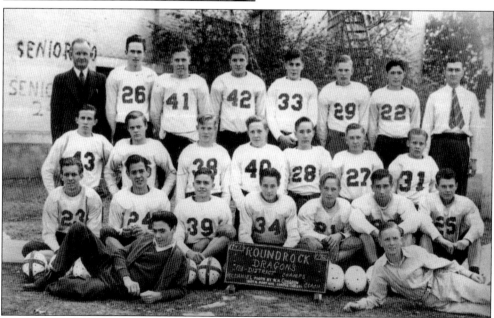

The 1941 Round Rock Dragons, coached by Supt. O. F. Perry, went 9-1-1, winning the district championship and defeating Marble Falls in a bi-district playoff game. Many of the players joined the armed services after graduation in 1942, and three of them—Chester Johnson (No. 41), W. O. "Bo" Warren (No. 34), and Leslie McNeese (No. 25)—met each other again on April 1, 1945, on the beach of Okinawa in the Pacific. (Courtesy Martin Parker.)

Andrew J. Nelson was born in Sweden in 1835 and came to America at the age of 21 with his family. He bought land near Round Rock and established a farm, leaving during the Civil War to enlist in the transport service to bring supplies to the Confederacy. Upon his return, he added cattle ranching to his growing list of business enterprises. He married Hedwig Nelson in 1870, and four of their nine children survived to adulthood. Andrew died in 1895, just as construction began on the grand Nelson family home on Main Street. (Courtesy *New Encyclopedia of Texas*, Ellis Davis and Edwin Grobe, Texas Development Bureau, Dallas, 1926.)

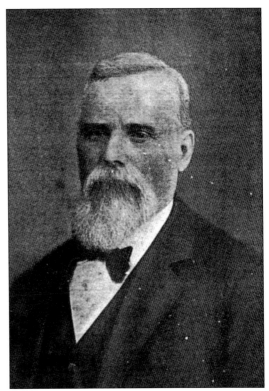

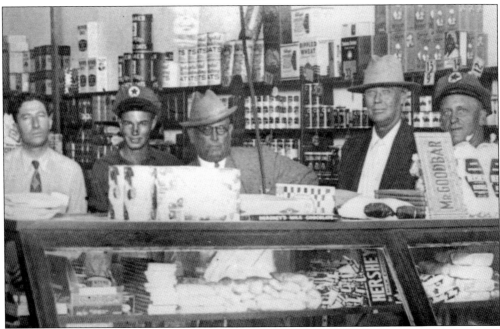

Hoyt Crimm operated a downtown grocery store and meat market in the 1920s and 1930s. His wife, Jimmie, was a schoolteacher as well as president of the Parent Teacher Association in 1939. This photograph of Crimm's store is dated 1936, and Hoyt is the man in the center wearing the hat and glasses. (Courtesy Martin Parker.)

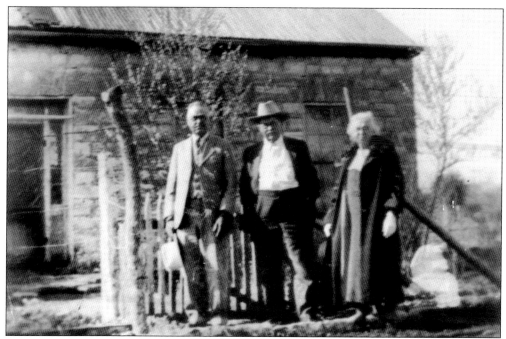

From left to right, Dudley Snyder Barker (1873–1952), Emery Taylor "Emzy" Barker (1870–1930), and Sally Appleton Barker Darlington (1864–1953) stand in front of their childhood home in Round Rock around 1929. Dudley, by then a renowned Texas Ranger and sheriff, returned to the house in 1940 on his 67th birthday and commemorated the event by writing his name and the date, still visible, on the interior plaster. (Courtesy Texas Historical Commission.)

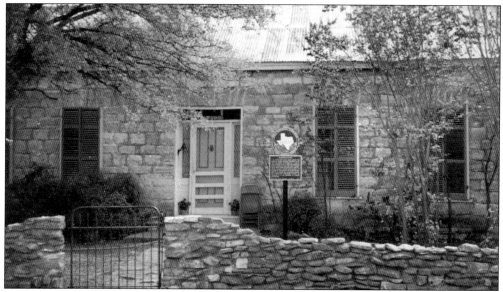

This house, built before 1873, was home to E. B. and Mary (Harvey) Barker, who moved their family from Taylor to Round Rock during winters so their eight children could attend the Greenwood Masonic Institute. Their son Dudley became a Texas Ranger and was later sheriff of Pecos County for 24 years. The house was designated a Recorded Texas Historic Landmark in 1998. (Courtesy author's collection.)

William McKenzie Bowden (1869–1930) was orphaned at the age of three and was raised by Dr. J. C. Black. His first job was assisting with the construction of the 1880s state capitol in Austin. He married Ida Robinson of Austin, and they had four children. Bowden was the manager of the Round Rock telephone office for about 20 years beginning in 1907. (Courtesy Martin Parker.)

In the early 20th century, church congregations provided communities with a strong social structure that supplemented families. Picnics, revivals, and reunions were popular church-sponsored activities. John Burns, Earl Haskins, and Jim McConnachie visited Round Rock for gospel revivals in the mid-1910s. (Courtesy author's collection.)

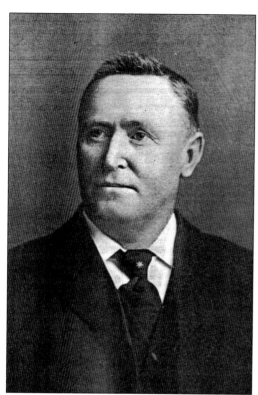

Sylvester V. Dooley was born in Killkinney County, Ireland, in 1852. He immigrated to the United States at the age of 17, settling first in New York City and then moving to Austin in 1872 as a clerk in the Walter Tips Hardware Company. He moved to Round Rock in the early 1880s and operated the Dooley Hardware Company until it was destroyed by fire in 1902. He married Ludie S. Haynes in Round Rock in 1884 and died in Austin in 1911. (Courtesy *New Encyclopedia of Texas*, Ellis Davis and Edwin Grobe, Texas Development Bureau, Dallas, 1926.)

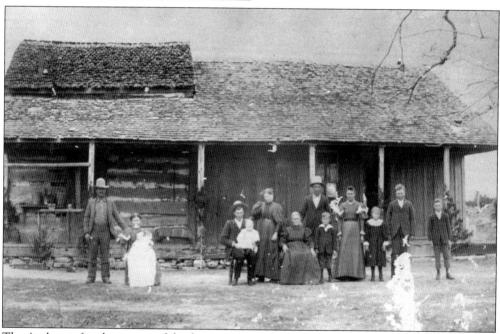

The Anderson family was one of the first to arrive in Williamson County after its organization in 1848. They built this home in 1849 west of Round Rock, and it stood for more than a century. This family portrait was made in front of the house in 1898, with three generations of the Anderson family pictured. (Courtesy Martin Parker.)

Cattle driving was a significant, regional, economic activity following the Civil War. The journey to Kansas on horseback took about three months to complete and was a dangerous trip. Harriet (Standefer) Cluck of Williamson County accompanied her husband on such a trip in 1871. At the time, the Clucks had three children and 25-year-old Harriet was more than six months pregnant. She was one of the first women to ever drive cattle from Texas to Kansas. (Courtesy Martin Parker.)

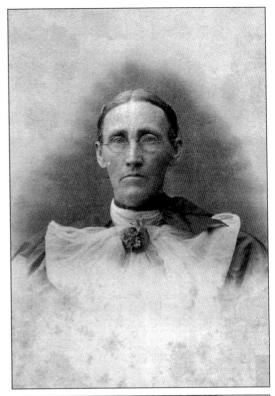

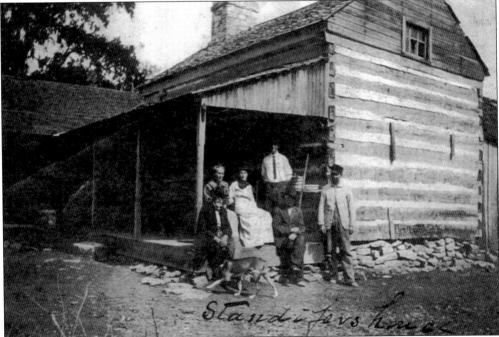

The Standefer family built this home between Round Rock and Cedar Park in 1846. Alabama-native Harriet Standefer married George Washington Cluck in Williamson County in 1863. George and Harriet Cluck are buried in Cedar Park Cemetery. (Courtesy Martin Parker.)

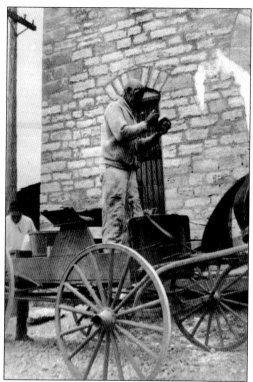

Clem Harvey fought in the Civil War as a private in the 15th U.S. Cavalry, Company H. Later he was a farmer near Round Rock. He is pictured here around 1900, when he was a delivery man for the W. J. Walsh store. His wife, Nancy, was also a domestic servant for the Walsh family. (Courtesy Martin Parker.)

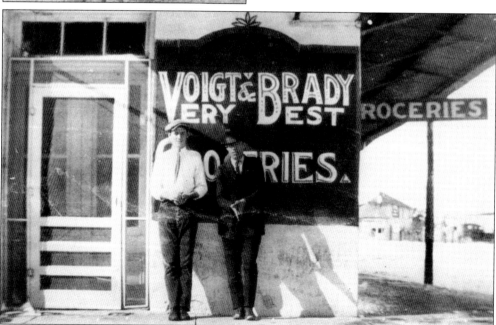

Morris Ledbetter (left) and Lex Voigt stand beside the Voigt and Brady Grocery Store at the southwest corner of Main and Lampasas Streets in the early 1920s. This building, which had been the W. J. Walsh store, was C. C. Bradford's general store in the 1900s. Voigt and Oscar Brady owned the business during the 1920s, and Kelley's Cleaners has made the building its home since 1957. (Courtesy Martin Parker.)

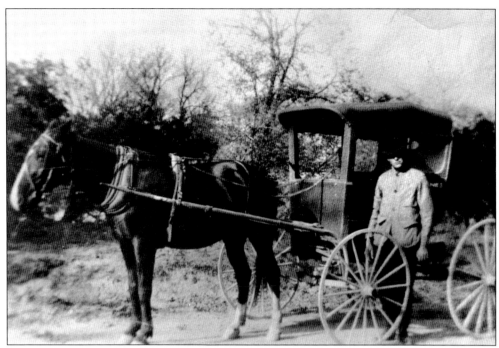

Charles Prewitt carried mail on Rural Route 1 out of Round Rock, an itinerary that took him generally west of town. He is pictured here with his horse-drawn mail buggy in 1917. Prewitt delivered the mail from 1916 to 1941. (Courtesy Martin Parker.)

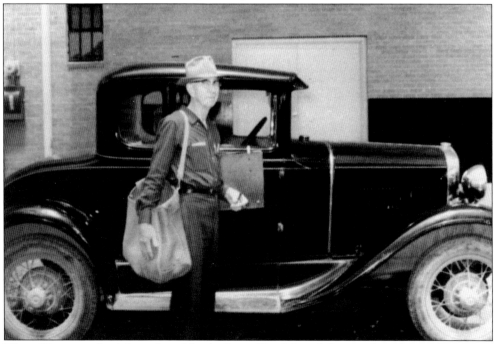

Edward Peterson also delivered mail for the Round Rock Post Office, working from 1923 to 1960. He started on foot and on horseback but by 1928 used a Model A car. He used the same car until his retirement some 32 years later. (Courtesy Martin Parker.)

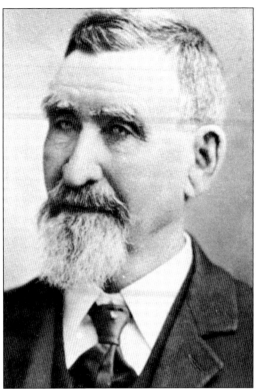

William Walsh was born in Ireland and served in the U.S. Navy during the Civil War. He worked for the U.S. Army in Texas after the war, producing lime for the construction of buildings at Fort McKavett. In 1869, Walsh established a lime works along the Colorado River near Austin. He moved his operation to Round Rock in 1896 as the Round Rock White Lime Company. (Courtesy Martin Parker.)

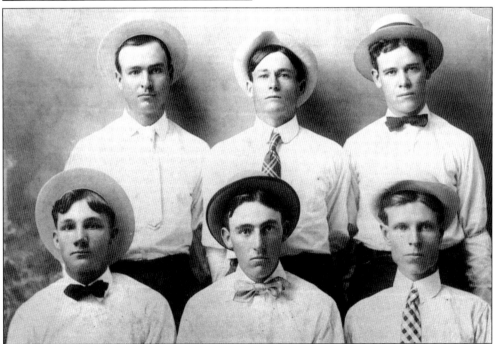

This *c.* 1907 photograph of young businessmen includes, from left to right (first row) Walter Henna, Wallace Bradford, and Harris L. Stockbridge; (second row) John A. Hyland, Norman Egger, and Skeet Thorp. (Courtesy Martin Parker.)

Rev. Johan Anderson Stamline, a Lutheran minister, was the first president of Round Rock's Trinity College when it opened in the fall of 1906. His residence, known as the President's House, still stands on South Georgetown Street. Stamline was born in the Smaland district of Sweden in 1853, immigrating to the United States in 1869 and first working in the area in the 1870s. (Courtesy Trinity College's 1919 yearbook, *The Round Rock*.)

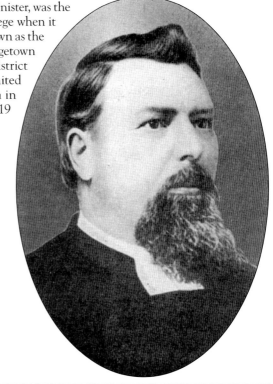

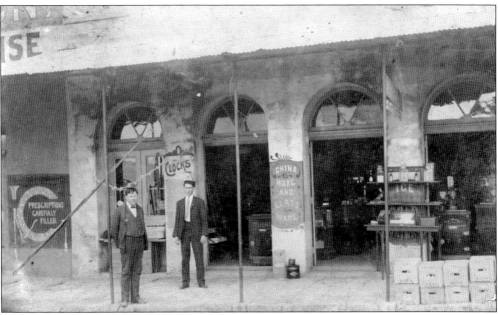

Simeon A. Pennington (1866–1912) was a downtown merchant active from the late 1880s to the late 1900s. He owned and operated a confectionery, a jewelry store, and also a skating rink he opened in Round Rock in 1906. He and his wife, Jennie (1870–1956), are buried in the Round Rock Cemetery. In this picture, Pennington is on the left outside his jewelry store. The other person is unidentified. (Courtesy author's collection.)

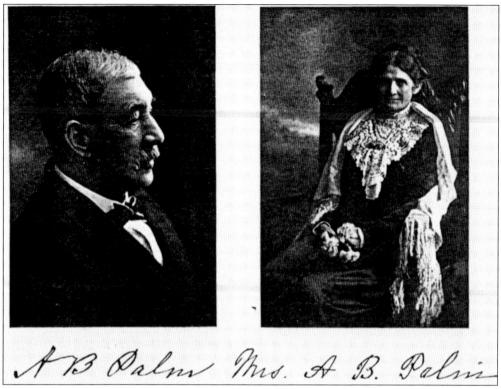

August B. Palm was born in Besthult, Sweden, in 1834. He came to Texas with his family in 1848, settling in Fort Bend County before coming to land just east of Round Rock that was later named Palm Valley in honor of his mother, Anna. August married Adela Belle Atwood in 1861, and during the Civil War, he and four brothers served in the Confederate army, with his youngest brother, Henry, staying home on the farm. August has been credited as the first person to plant cotton in Williamson County, later erecting a cotton gin on his 700-acre farm. (Courtesy A *History of Texas and Texans*, Frank Johnson, American Historical Society, Chicago, 1914.)

Rev. Freeman Smalley was born in Pennsylvania in 1790, and his family moved to Ohio in 1792. He fought in the War of 1812. He became an ordained minister and gave one of the first Baptist sermons in Texas at his cousin Rachel Rabb Newman's home in Red River County in 1822. Smalley and his family moved to Round Rock in 1849. Prior to the Civil War, the family was active in forming the Anti-Slaveholding Union Baptist Church. The church's cemetery, which includes some Smalley family burials, was given a state historical marker in 1987. (Courtesy Texas Historical Commission.)

John Peterson and Betty Olson came to Round Rock in the 1870s from Norway. John was one of the first blacksmiths in town, building a shop between West Main Street and Round Rock Avenue. They married in Georgetown in 1880. Pictured here are their two daughters, Lillie (left) and Nina, in about 1890. A fire destroyed John's blacksmith shop in the 1880s, and he rebuilt across the street. John and Betty are buried at the Palm Valley Lutheran Church Cemetery. (Courtesy Martin Parker.)

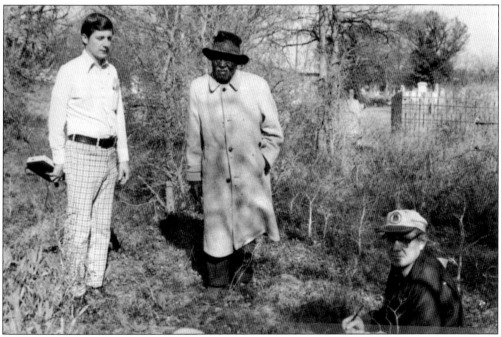

Joe Lee Johnson was born in 1882. His father and grandfather, both named Simon Johnson, were born as slaves and were buried in the northwest corner of the Round Rock Cemetery. Here in 1977, from left to right, H. R. Richardson, Johnson, and M. M. Ham survey the historic graveyard. Johnson helped identify known burials of former slaves in the cemetery, including his father and grandfather. Johnson died in 1977 at the age of 95, and two years later, the state placed an official historical marker for the Slave Burial Ground. (Courtesy Texas Historical Commission.)

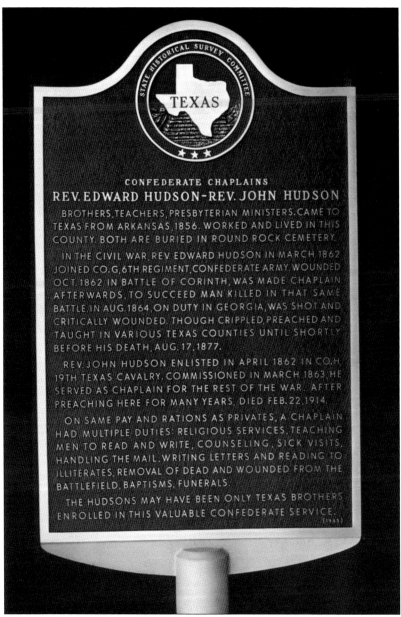

CONFEDERATE CHAPLAINS
REV. EDWARD HUDSON-REV. JOHN HUDSON
BROTHERS, TEACHERS, PRESBYTERIAN MINISTERS. CAME TO
TEXAS FROM ARKANSAS 1856. WORKED AND LIVED IN THIS
COUNTY. BOTH ARE BURIED IN ROUND ROCK CEMETERY.

IN THE CIVIL WAR, REV. EDWARD HUDSON IN MARCH 1862
JOINED CO.G, 6TH REGIMENT, CONFEDERATE ARMY. WOUNDED
OCT. 1862 IN BATTLE OF CORINTH, WAS MADE CHAPLAIN
AFTERWARDS, TO SUCCEED MAN KILLED IN THAT SAME
BATTLE. IN AUG. 1864, ON DUTY IN GEORGIA, WAS SHOT AND
CRITICALLY WOUNDED. THOUGH CRIPPLED, PREACHED AND
TAUGHT IN VARIOUS TEXAS COUNTIES UNTIL SHORTLY
BEFORE HIS DEATH, AUG. 17, 1877.

REV. JOHN HUDSON ENLISTED IN APRIL 1862 IN CO.H,
19TH TEXAS CAVALRY. COMMISSIONED IN MARCH 1863, HE
SERVED AS CHAPLAIN FOR THE REST OF THE WAR. AFTER
PREACHING HERE FOR MANY YEARS. DIED FEB. 22, 1914.

ON SAME PAY AND RATIONS AS PRIVATES, A CHAPLAIN
HAD MULTIPLE DUTIES: RELIGIOUS SERVICES, TEACHING
MEN TO READ AND WRITE, COUNSELING, SICK VISITS,
HANDLING THE MAIL, WRITING LETTERS AND READING TO
ILLITERATES, REMOVAL OF DEAD AND WOUNDED FROM THE
BATTLEFIELD, BAPTISMS, FUNERALS.

THE HUDSONS MAY HAVE BEEN ONLY TEXAS BROTHERS
ENROLLED IN THIS VALUABLE CONFEDERATE SERVICE.
(1965)

Brothers Edward and John Hudson were born in Lawrence County, Arkansas. Both were ordained by the Cumberland Presbyterian Church. John married Canzadia Adaline Hamilton in 1855 and preached and taught school in San Saba County in the late 1850s. In April 1862, John enlisted as a private in the Confederate army, serving in Burford's 19th Texas Cavalry. He was commissioned a chaplain in 1863. Edward also served as a chaplain, in the 6th Cavalry, CSA. Edward was badly wounded but returned to Central Texas to preach and teach school before his death in 1877. John and Canzadia had 10 children, moving as John served churches at Bagdad, Hutto, Lampasas, Gabriel Mills, Liberty Hill, and Round Rock, as well as in Missouri. John also edited the *Church Helper* newspaper and established a home in Round Rock for retired Presbyterian ministers. The state awarded a historical marker to the Confederate chaplain brothers in 1964. (Courtesy Texas Historical Commission.)

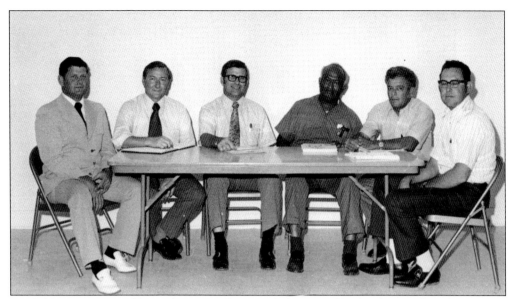

Garfield McConico and his wife, Petronella, attended Hopewell School, Round Rock's separate school for African American students, before the schools were integrated in 1966. Petronella also taught in Round Rock schools for 32 years, and Garfield was elected as the city's first African American city councilman in 1969, serving eight years. This 1972 photograph shows the city council from left to right: Ray Litton, James Toungate, Mayor Dale Hester, Garfield McConico, Marcelo Beltran, and Gene Parker. (Courtesy Martin Parker.)

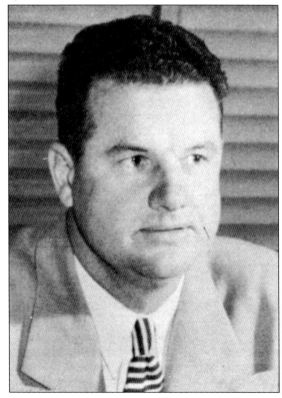

Louis Henna was a Round Rock native, born here in 1914 and graduating from high school in 1931. He borrowed money to open a service station and later expanded into car sales. Henna served on the city council and as mayor, and he and his wife, Billie Sue, founded the Texas Baptist Children's Home. (Courtesy *Central Texas Business and Professional Directory*, William Skaggs, ed., Austin: Centex Publications, 1951.)

Kansas native Elmer Cottrell, working for Armour and Swift, was transferred to Round Rock in 1948 to manage the Round Rock Cheese Factory. The following year, the plant manufactured 600,000 pounds of cheese from local dairymen. Cottrell became president of the Round Rock Chamber of Commerce. (Courtesy *Central Texas Business and Professional Directory*, William Skaggs, ed., Austin: Centex Publications, 1951.)

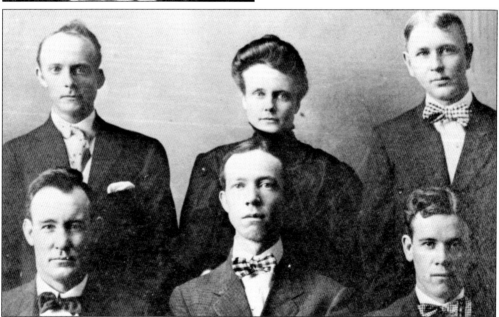

C. J. Anderson, G. A. Peterson, and J. A. Nelson chartered the Anderson-Peterson Mercantile, a cooperative merchandise store at the northeast corner of Lampasas and Main Streets, in December 1898. In March 1904, the company changed its name to the Round Rock Mercantile. This c. 1910 photograph shows owners, from left to right, (first row) Jack Jordan, Elmer Black, and Skeet Thorp; (second row) James Carlson, Emma Peterson, and Eric Swenson. (Courtesy Martin Parker.)

Two

ALL ROADS LEAD TO ROUND ROCK

By the time the frontier of settlement advanced westward across Central Texas, settlers were locating their homes sporadically along the rivers and creeks. Eventually enough people would be living in an area to organize counties and form towns and villages. An early fort was established on Block House Creek near Leander in 1835. Dr. Thomas Kenney brought his family from Bastrop in the late 1830s to Kenney's Fort, a landmark that was at the crossroads of history during the Republic of Texas. Where the Military Road crossed Brushy Creek and the San Gabriel River, people coalesced into villages and small towns. After Williamson County was created and organized in 1848, settlements that were large enough petitioned for post offices to make their names known across the land. The earliest post offices were established for Brushy, which changed to Georgetown; Brooksville, which changed to Florence; and Post Oak Island, a now-extinct town southeast of Taylor.

Soon Round Rock was a regular stage stop on the road to Austin, and it began to thrive. The people built homes and general stores, cultivated farms, and started grain mills powered by the creek. The citizens continued to help their hometown succeed, growing crops, raising horses, starting families, trading with nearby towns, and doing the things that tied them with their neighbors, their state, and their country. In the 1852 election for president, Williamson County and Texas went the way of the nation in electing Franklin Pierce over Winfield Scott. Some of the earliest religious and social organizations in town, such as the First Baptist Church and the Masonic Lodge, date from these earliest days. Some of the oldest homes and stores in town still stand today, and many are designated with historical markers. They represent the diverse social and economic forces that shaped the early development of the town.

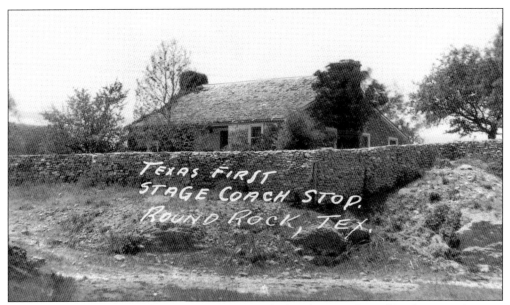

John Harris built a stagecoach stop in 1848, six years before the name Round Rock was on the map. The main stage ran from San Antonio to Austin through here and on to Georgetown, Belton, and northeast into Arkansas. Stages traversed Brushy Creek at the round rock of limestone that was a landmark for a low-water crossing. The original stage stop of large limestone blocks, with some additions and alterations, was still standing more than 150 years after its construction. (Courtesy author's collection.)

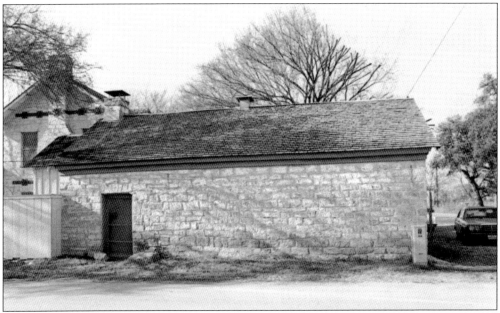

The growing village received a post office in 1851 called Brushy Creek, marking an official recognition of the settlement's viability. Thomas Oatts built this combination house and store that served as the first post office. In 1854, he changed the postal name to Round Rock to commemorate the limestone formation in the middle of Brushy Creek from which he and friend Jacob Harrell spent many hours fishing. (Courtesy Texas Historical Commission.)

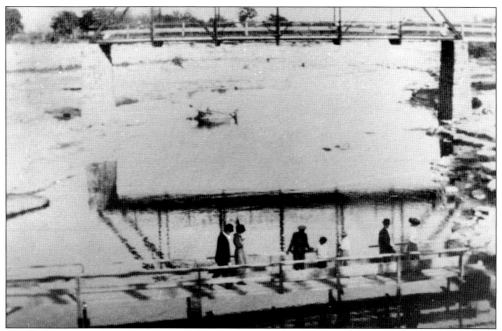

This picture shows a low-water pedestrian crossing, near the start of the 20th century, across Brushy Creek a short distance from the round rock. The higher wagon crossing is in the background closer to the rock. The road past the round rock was first low, subject to being inaccessible during flooding, then high after the wagon crossing was built. (Courtesy Martin Parker.)

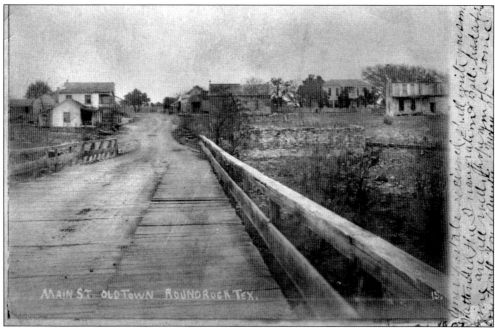

This rare view of the road leading from Austin into Round Rock is from just after 1900. This was a high-water crossing of Brushy Creek leading into Old Town. Looking north, the historic Sansom House is to the left of the road, the Mays and Black store is to the right of the road, and a community church building is on the far right. (Courtesy Martin Parker.)

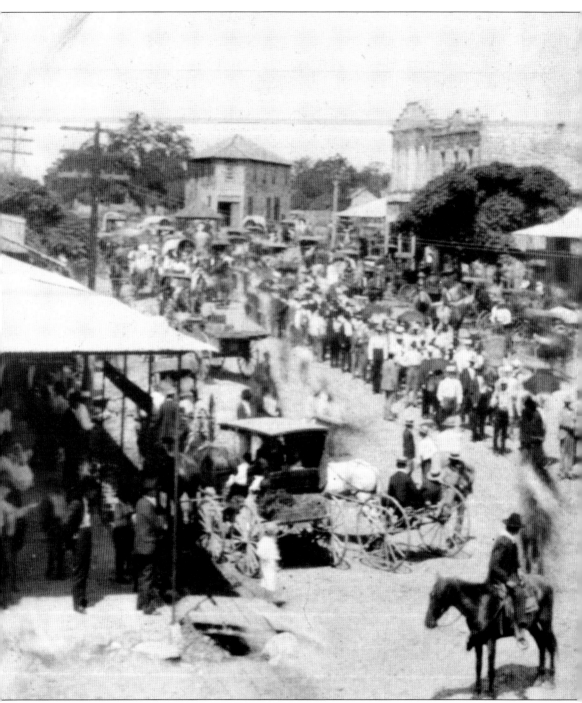

A parade goes down Main Street around 1898. Leading the parade are soldiers of the Spanish-American War, followed by citizens whose buggies are visible near the upper left. Note the two-story, triangular building at upper left, which took advantage of the angle that Round Rock Avenue makes with Main Street. A blacksmith shop and later an automobile garage were at this

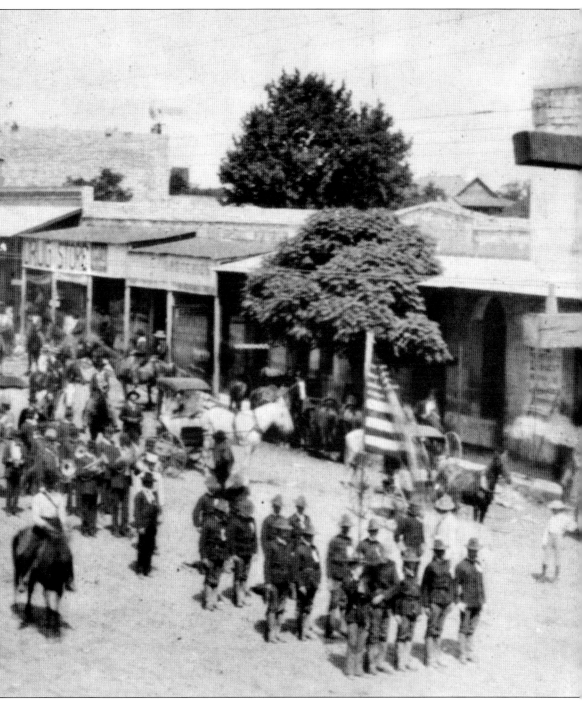

location. The two-story broom factory building and the Otto Reinke Building are visible farther right, followed by a series of one-story buildings with projecting wooden awnings. Also visible on Main Street are telephone/telegraph lines and a few trees growing in the unpaved street. (Courtesy Martin Parker.)

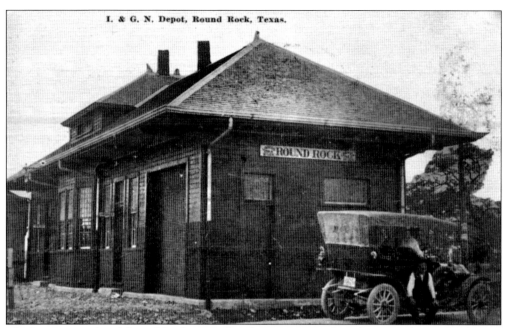

I. & G. N. Depot, Round Rock, Texas.

The International and Great Northern Railroad came to Round Rock in 1876, having built from the east. The railroad stopped nearly a mile short of the existing town, creating a newly platted Round Rock on land that had belonged to Washington Anderson. A sale of lots on July 4, 1876, brought a large crowd from Austin and surrounding towns. The depot became the center of activity, bringing visitors, new residents, and commerce. The depot pictured here replaced the original. (Courtesy author's collection.)

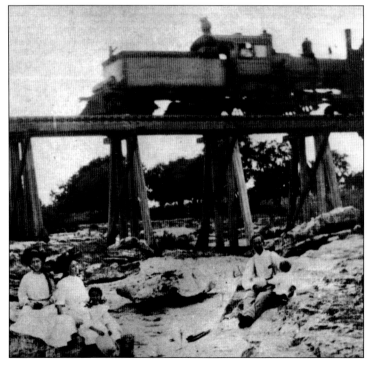

A 1904 image shows the W. J. Walsh family enjoying a picnic between the round rock and the railroad bridge. The Georgetown Tap was established soon after the International and Great Northern Railroad came to Round Rock, connecting the town with the Williamson County seat. The picture shows the Georgetown Tap's 4-4-0 coal-burning locomotive. Jim Doughty was the engineer, and John Hall was the brakeman. (Courtesy Martin Parker.)

Workers repair the damage to the wagon road into Old Round Rock from a 1913 flood. The limestone supports and road were first built in 1891 by the Chicago Bridge and Iron Company through Williamson County Commissioners Court. During World War II, metal from the bridge was salvaged for a scrap drive, and the road became a low-water crossing. (Courtesy Martin Parker.)

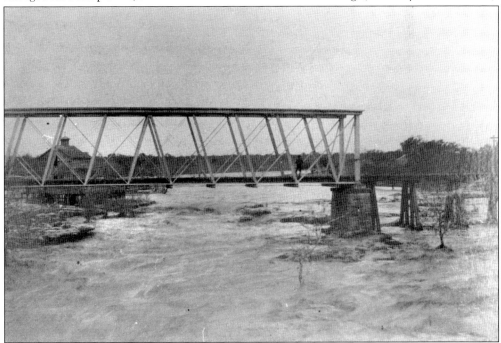

An image dated January 10, 1900, shows rising floodwaters on Brushy Creek and a man standing on the railroad bridge. A gristmill is visible at the left side of the picture. Local creeks and rivers also suffered major flooding in 1899, 1913, 1921, and 1935. (Courtesy Martin Parker.)

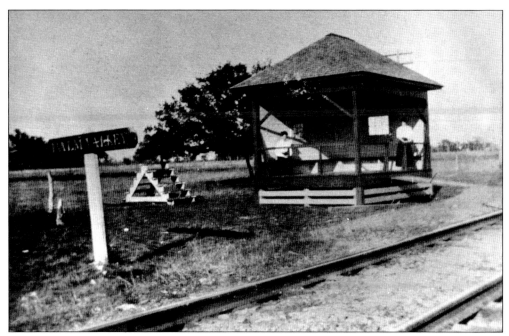

The Missouri, Kansas, and Texas Railroad (MKT or Katy) built just to the east of Round Rock in 1904. The railroad established whistle stops called Nelson, Burkland (Burklund), and Palm Valley in the area. In this photograph, two women wait for the train at the small shelter at the Palm Valley stop, located just west of Palm Valley Lutheran Church. (Courtesy Martin Parker.)

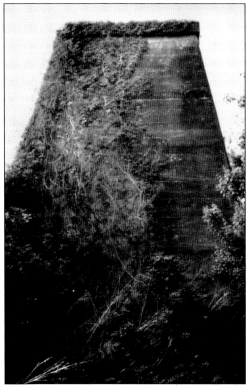

After the Missouri, Kansas, and Texas Railroad line running just east of Georgetown and Round Rock ceased operations, the tracks were taken up and most evidence of the railroad was erased. This concrete abutment near Palm Valley remains near Brushy Creek, stamped with the date "1904." (Courtesy author's collection.)

The Smith Hotel operated in the 1870s and 1880s on West Bagdad Street, just north of the International and Great Northern Railroad tracks and a few blocks west of the depot. The proprietor was Emily Smith, the mother of notorious Old West con man Jefferson Randolph "Soapy" Smith. After she died, Soapy developed a criminal empire in Denver and Creede, Colorado, and Skagway, Alaska. (Courtesy Martin Parker.)

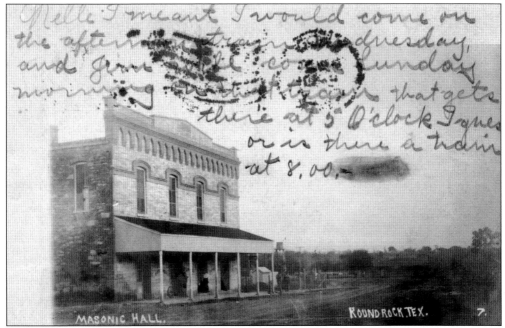

The 1878 Masonic Hall and Post Office in New Town is pictured in 1907. Under the wooden awning, a man with a bicycle stands beside a painted sign that reads "Post No Bills." The dirt road in front of the building passes the railroad depot and heads south toward Austin. (Courtesy author's collection.)

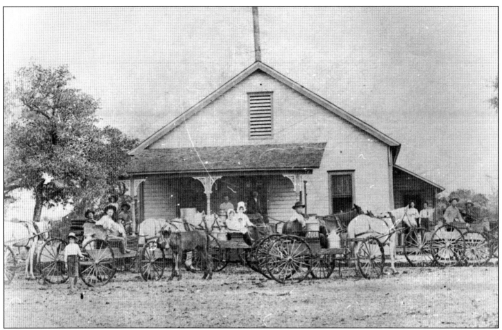

The Round Rock Creamery was established in 1904 on the north bank of Round Rock along the old Georgetown road. The operation was intended to provide a means for farmers to make extra money by selling milk to the creamery, which in turn processed it into cheese, cream, and other products. The business failed after a few months. (Courtesy Martin Parker.)

On nearly the same site as the 1904 Round Rock Creamery, the Round Rock Cheese Company was built in 1928. This became the first successful cheese factory in the state, and in 1929, Armour and Swift of Fort Worth bought the business and expanded it. When the boll weevil destroyed area cotton crops and the Great Depression exacerbated reduced agricultural prices, the cheese factory was crucial to Round Rock's economy in the 1930s. (Courtesy Martin Parker.)

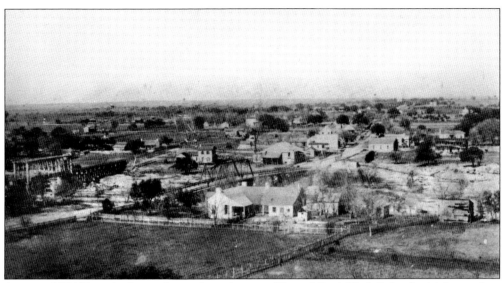

A view of Old Town looks northwest from the top of Round Rock High School, which was then near the current intersection of Interstate 35 and 620. The railroad bridge at left washed out in a 1900 flood. The Austin-Georgetown road can be seen running from the left of the photograph to the top right. (Courtesy Martin Parker.)

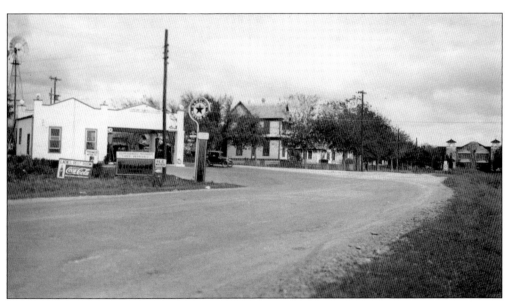

This is State Highway 2 in the 1920s, coming down what is now Georgetown Street at the top left and turning on to Main Street in the foreground. A filling station was strategically placed at the northwest corner of the turn. Round Rock's position on State Highway 2 helped ensure a steady stream of commerce and tourists in the early days of automobile travel. (Courtesy City of Round Rock.)

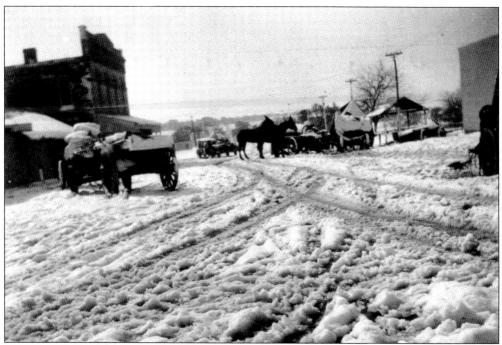

Extreme weather conditions could make travel through the area difficult and sometimes dangerous. This photograph shows a view looking south down Mays Street following a rare snowfall in 1922. (Courtesy Martin Parker.)

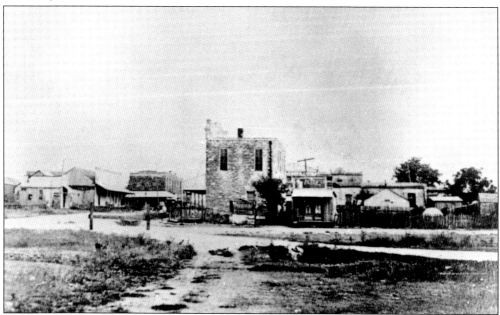

When the International and Great Northern Railroad came in 1876, it platted a new town nearly a mile east of the existing settlement. The new town took the postal name of Round Rock and was also known as New Town, while the established town took the postal name of Old Round Rock and was also known as Old Town. This photograph was taken from the depot looking north into New Town around 1890. (Courtesy Martin Parker.)

Dudley Pennington, co-owner of Buckner and Pennington Livery and Feed Stable, is shown in an undated photograph of a rare snowfall. Rain and snow could render unpaved area roads and trails impassable in the early 20th century. (Courtesy Martin Parker.)

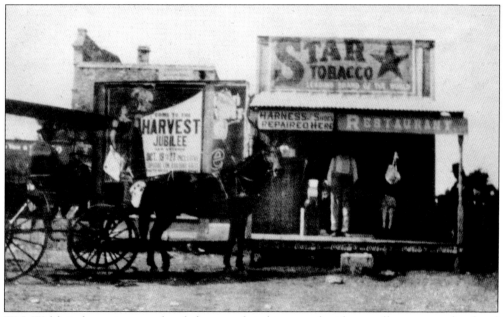

W. J. Walsh is shown in an undated photograph in his surrey beside a small restaurant that faced the railroad depot. This would be the first view of Round Rock visitors would get when they came to town by train. (Courtesy Round Rock Chamber of Commerce.)

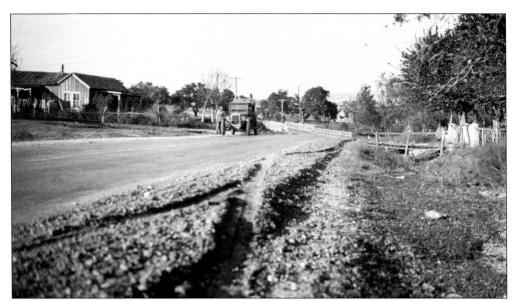

State Highway 2 is shown here, entering Round Rock from the south. The quality of early roads was inconsistent at best, and even this major state highway that ran from Austin to Dallas was not immune to erosion by weather and extreme wear and tear. (Courtesy City of Round Rock.)

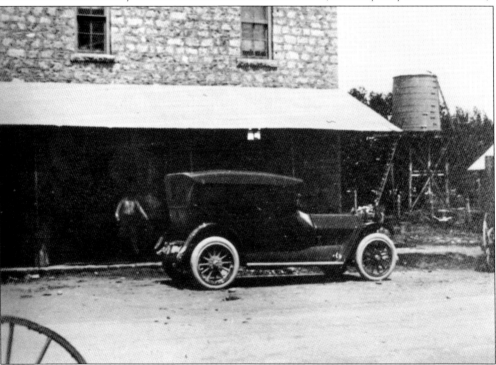

Automobiles were slow to replace horse-drawn vehicles in the early 20th century, partly because the quality roads to support the cars were not available. In 1907, only 23 cars were registered in Williamson County, including three in Round Rock (to T. M. Harrell, C. A. Nelson, and J. A. Nelson). This undated photograph shows an early car in downtown Round Rock. (Courtesy Martin Parker.)

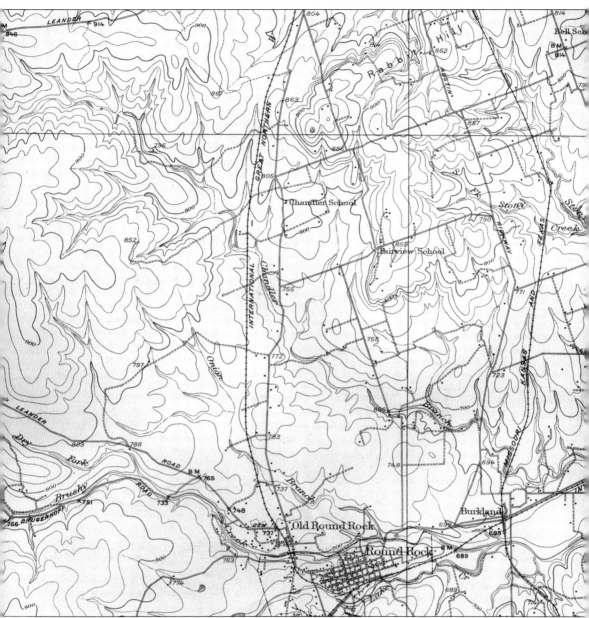

A view of Round Rock and the surrounding area is depicted in this 1928 topographic map. A north-south road from Georgetown parallels the historic Georgetown Tap Railroad (by this time part of the International and Great Northern line). The road itself shows periodic jogs as the road went around property lines and other obstacles. The Austin Highway (State Highway 2) is farther east, traveling along what is now Georgetown Street and Farm to Market 1460 parallel to the Missouri, Kansas, and Texas Railroad. Note the rail stop named Burkland (Burlund) on the MKT. Old Round Rock and Round Rock are portrayed as truly separate communities on this map. Roads to the west lead to Leander and Bruegerhoff (Cedar Park). Besides local roads and trails, several rural schools, including Bell, Chandler, Fairview, and Stony Point, are shown. The Round Rock city limits were bounded by Brushy Creek on the north and Lake Creek on the south. (Courtesy 1928 Round Rock quadrangle, United States Geological Survey.)

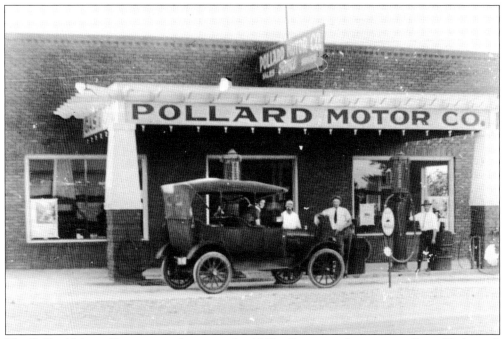

The Pollard Motor Company is shown in the 1920s. Due to its location on State Highway 2 and later U.S. 81, both major roads between Austin and Dallas, Round Rock supported several automobile dealers and repair shops. The Pollard Motor Company building, later the Round Rock Motor Company, was located where the Round Rock Public Library now stands on Main Street. It was destroyed by fire in 1929. (Courtesy Martin Parker.)

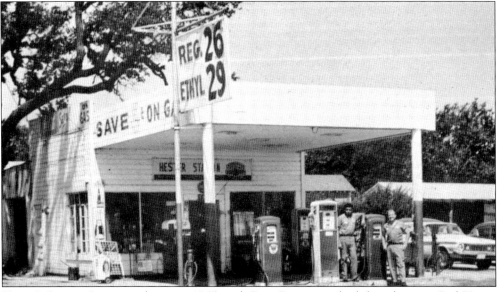

Hester's Service Station is shown in 1965, with Pete Correa on the left and owner Gail Hester on the right. Correa would later open his own auto repair shop and would serve for several years on the Round Rock City Council. Hester Automotive and Body Shop was still in operation when gasoline cost 10 times what it did in this photograph. (Courtesy Round Rock Chamber of Commerce.)

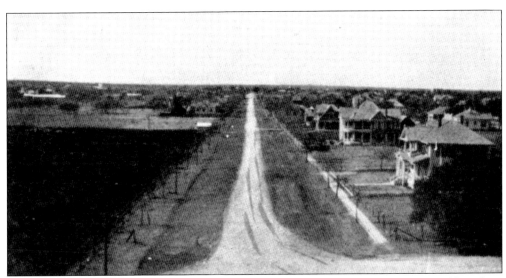

This view looking west down Main Street from the top of the Trinity College main building dates from 1919. On the right, several two-story homes are visible, including the President's House, built by Trinity for the college president and later moved one block southwest to Georgetown Street. To the left, agricultural fields are visible between Main Street and the railroad. Even the main road through Round Rock was unpaved at this time. (Courtesy Trinity College's 1919 yearbook, *The Round Rock*.)

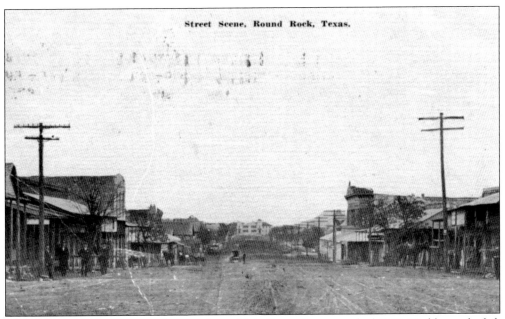

This postcard with a view to the east down Main Street is postmarked 1910. Visible on the left is the two-story Morris Meyer building, which burned in 1915. The two-story Nelson Building is on the right. Because Round Rock's population was relatively stable between 1880 and 1970, numbering less than 3,000 people, the buildings in the commercial district were relatively unchanged a century after they were built. The four blocks around Lampasas and Main Streets were listed on the National Register of Historic Places in 1983. (Courtesy author's collection.)

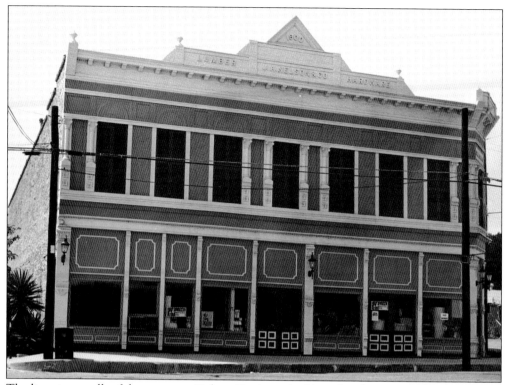

The limestone walls of the two-story Nelson Hardware building date from soon after the railroad town of Round Rock was established in 1876. An 1899 fire gutted the existing building. In 1900, the Nelson family renovated the building and had a cast-iron and pressed-tin facade from Mesker Brothers of St. Louis, Missouri, installed on the Main Street entrance. The prominent cornice features brackets and a triangular pediment bearing the stamped construction date of 1900. (Courtesy Texas Historical Commission.)

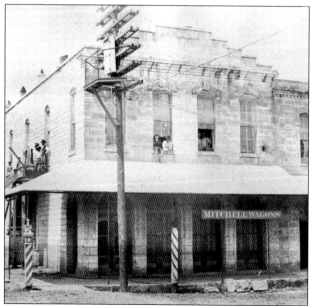

In 1880, R. D. Harris and W. A. Taliaferro built this two-story limestone building to house their grocery store. Later the building housed a furniture and crockery store, a confectionery and printing press, and then the Round Rock Broom Factory from 1900 to 1911. For more than 50 years, a carriage garage and then an auto garage operated here, even removing one of the front stone columns so cars could be driven inside. This *c.* 1920 photograph includes an advertisement for Mitchell Wagons. (Courtesy Martin Parker.)

Three

FOUNDATIONS

Settlers strived to get their communities on the map. The foundations of settlement, such as schools, churches, businesses, and post offices, gave towns commercial and social permanence. Later securing a railroad connection ensured that a town would continue to flourish. The defining economic engine of the 1870s was the arrival of the freight train. The International and Great Northern Railroad (IG&N), owned by Jay Gould, moved south and west from connections in St. Louis, Missouri, and Memphis, Tennessee, bringing goods and immigrants from the eastern United States to the developing Texas economy. When it was announced that the IG&N would build its line across Williamson County, new towns were platted along the railroad. Stiles Switch (later Thrall), Taylorsville (Taylor), and Hutto were all established in short order in 1876.

Then the railroad approached Round Rock, stopping nearly a mile east of the established town and platting a town site between Brushy and Lake Creeks. The IG&N stopped the tracks here for over a year, so Round Rock challenged Austin for economic control of Central Texas. Within a year, Round Rock boasted six hotels to Austin's five. Round Rock became the trading hub for 10 Central Texas counties that had no rail connection. From San Angelo, Brownwood, and Lampasas, people would come to town to see what the railroad would bring, from necessities like food, clothes, and building supplies, to luxury items and the latest news from the big cities to the east. Practically overnight, Round Rock became a boomtown, with some estimates putting the population at 2,000. The Austin newspapers seemed especially jealous that Round Rock offered vices such as billiards and whiskey.

The railroads brought amenities such as lumberyards, hardware stores, banks, blacksmiths, and drugstores. Round Rock's population also became much more cosmopolitan, with new settlers coming from all over the country and all around the world. They joined with the old-timers to lay the foundations for a community that was just beginning to grow.

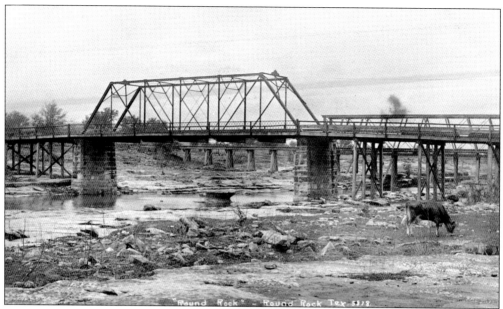

A 1908 view of Brushy Creek and the round rock looks southwest from the north bank. Settlers came to this stretch of Brushy Creek in the 1840s, and early horseback paths, stagecoach routes, and cattle trails utilized the low-water crossing marked by the unique limestone formation in the creek. The bridge and wagon road in the foreground were completed in 1891. (Courtesy author's collection.)

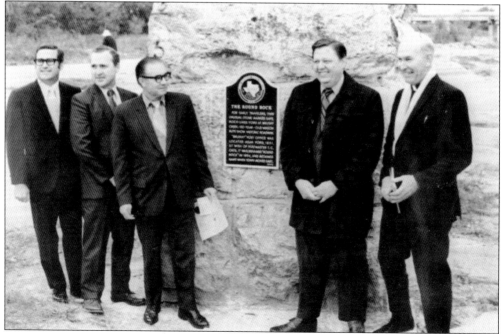

The round rock was considered notable enough that in 1971, the state awarded an official historical marker to the site. From left to right, Mayor Dale Hester, postmaster Martin Parker, Supt. Noel Grisham, Rev. James D. Watson, and Rev. Oliver Berglund attend the marker dedication ceremony. (Courtesy Martin Parker.)

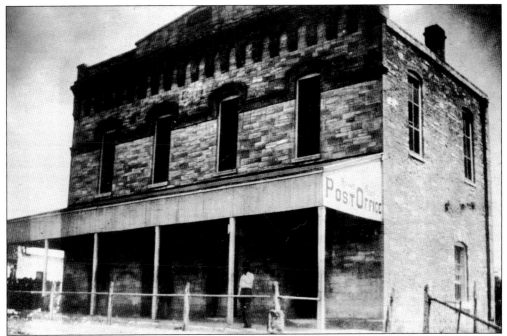

After New Town was established on the railroad, this combination post office building and Masonic Hall was built. The post office of New Town took the name Round Rock, while the established community name was changed to Old Round Rock. This building stands virtually unchanged just south of the intersection of Main and Mays Streets. (Courtesy author's collection.)

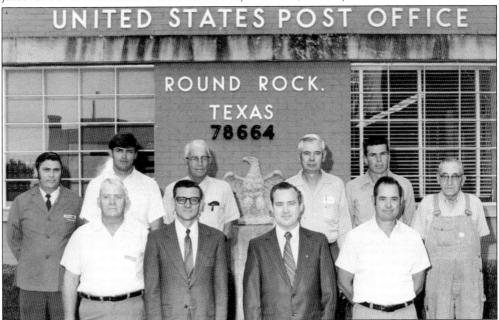

This was Round Rock's post office on Main Street in the 1960s when the town got its first zip code of 78864. From left to right are (first row) Clyde Dannelley, Conrad Zimmerman, Martin Parker, and Karl Krienke; (second row) Robert Foxworth, Richard Barber, J. M. Archer, Milton Krienke, Theodore Zimmerman Jr., and Harry Noren. (Courtesy Martin Parker.)

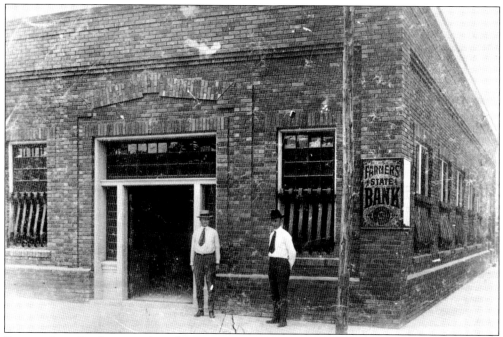

Farmers State Bank received its charter from the state in July 1920 and opened for business the following month at the northwest corner of Main and Lampasas Streets. A. W. Klattenhoff and Gus R. Lundelius stand in front of the building that housed the bank for 40 years. (Courtesy Martin Parker.)

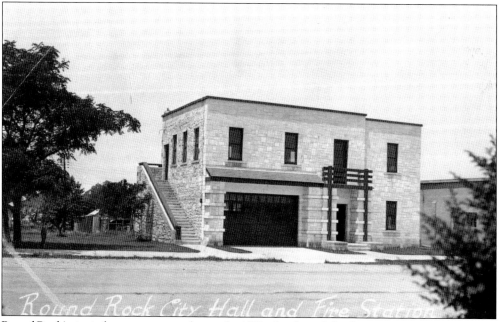

Round Rock's city infrastructure grew during the 1930s thanks to federal Depression-era construction programs. A combination city hall and fire station was built on Main Street and later incorporated into the downtown library. The first city sewer system was also built during the Depression thanks to funding from a federal construction program. (Courtesy author's collection.)

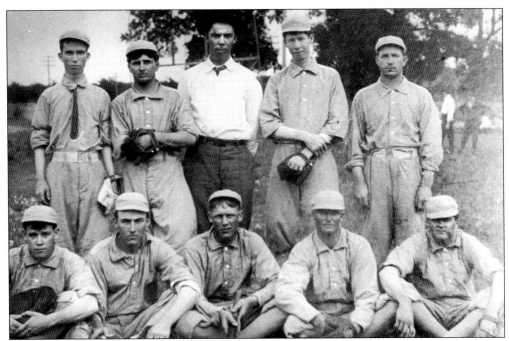

At the dawn of the 20th century, nearly every city and town in Williamson County fielded a town baseball team. Composed of young men associated with the town rather than the school, the teams played each other throughout the spring and summer months. Round Rock baseball results were reported in local newspapers as early as 1908. This undated photograph shows one of the earliest Round Rock town teams. (Courtesy Martin Parker.)

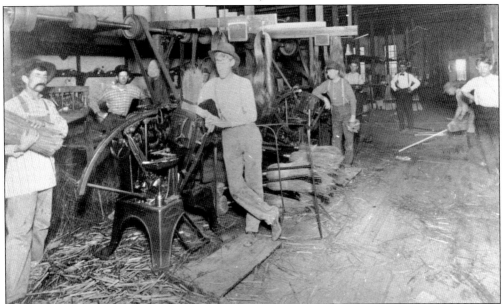

The Round Rock Broom Factory began in Old Town in 1876, moving to the two-story limestone building at the northeast corner of Main and Mays Streets in 1887. It became one of the largest broom factories in the state and a major employer in town. At the 1904 World's Fair in St. Louis, Missouri, a broom from Round Rock took first place in its division. (Courtesy Martin Parker.)

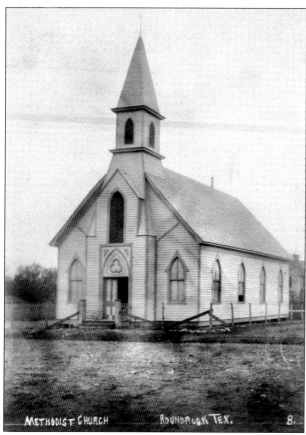

Round Rock's Methodist church was organized in 1879, with Rev. B. S. Lane as the first pastor. The first sanctuary, pictured here, was built on South Brown Street. Round Rock and Georgetown were considered circuit churches until 1897. The Epworth League, a youth ministry, was active in the early 20th century. From a period in the 1920s when Round Rock had just two services a month and shared a pastor with Weir, First United Methodist Church grew big enough to move to the U.S. 79 and U.S. 81 intersection in 1982, followed by the dedication of a large new sanctuary in 2003. (Courtesy author's collection.)

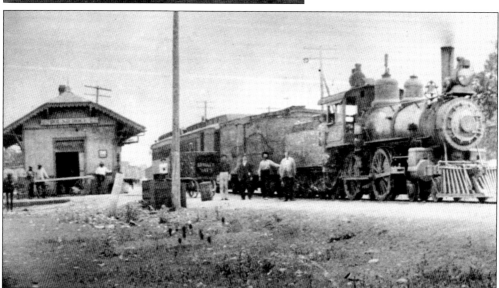

This photograph dates from 1904, showing Round Rock's first train depot at left and the coal-burning locomotive ready for its trip to Georgetown. Passenger and freight rail service was active in Round Rock from the 1870s to the 1970s, supplying the main transportation means to connect the city to regional and national markets. (Courtesy Martin Parker.)

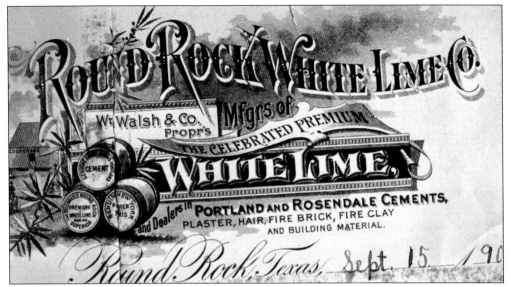

William J. Walsh began a lime works in Austin in 1879, moving the operation to Round Rock in 1896 and changing the name to Round Rock White Lime Company. For many years, the industry was the major employer in town, with a company store called the Fair on Main Street near a general store that Walsh also operated. A barrel of Round Rock lime won first prize at the 1904 World's Fair in St. Louis, Missouri. The company remained in operation until the early 1970s. (Courtesy Martin Parker.)

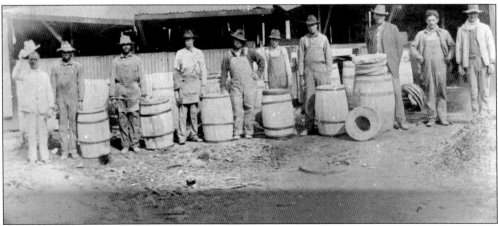

The Round Rock White Lime Company was a vast operation that provided job opportunities for area farmers and laborers, as well as great numbers of workers from Mexico. Natives of Mexico came to Williamson County by the hundreds in the 1900s and 1910s, and immigration increased because of political instability and unease associated with the Mexican Revolution. (Courtesy Martin Parker.)

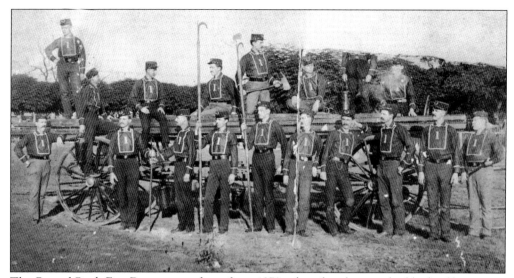

The Round Rock Fire Department dates from 1879, when fire destroyed a block of businesses on Main Street. A volunteer fire department was formed in 1884. An 1889 account mentions San Jose Hose Company No. 1 and a Hook and Ladder Company, and soon after, the first fire department building was completed. This 1907 photograph shows members of the Hook and Ladder Company. (Courtesy Martin Parker.)

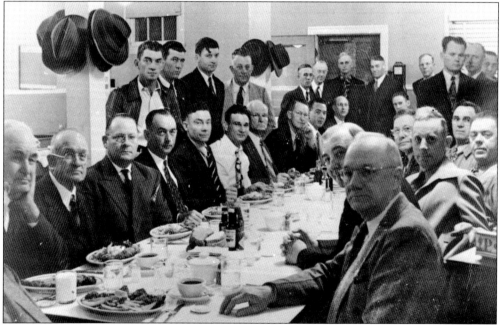

The Round Rock Fire Department enjoys a 1947 banquet at the S&S Grill. From left to right are (seated) Jack Jordan, Wallace Ledbetter, Oliver Carlson, M. O. Deison, Roy McMurtrie, Bill Fyke, H. L. Stockbridge, Reynold Burglund, Wallace Rucker, W. W. Rucker, Rev. ? French, L. O. Ramsey, C. D. Anderson, Larue Makemson, Fred Olson, C. V. Lansberry, and Walter Henna; (standing) Pete Hester, Leroy Behrens, Leroy Forrest, O. T. Bengston, Dick Mayfield, D. B. Gregg, Peaches Ferrell, Robert Egger, Charles Boatner, Charles Brotherman, Cody Adolphson, and Brady Anderson. (Courtesy Martin Parker.)

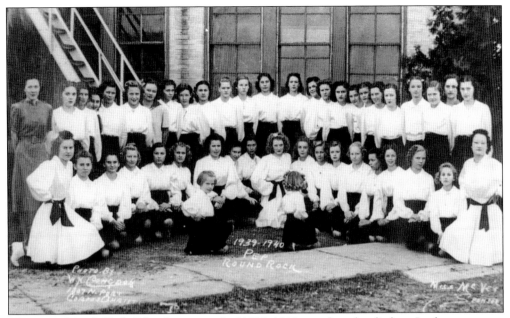

The Round Rock High School pep squad of 1939–1940 was the school's first. In the same year, the school band was established, and the school fight song and school song, to the tunes of "On Wisconsin" and "High Above Cayuga's Waters," respectively, were composed. (Courtesy Martin Parker.)

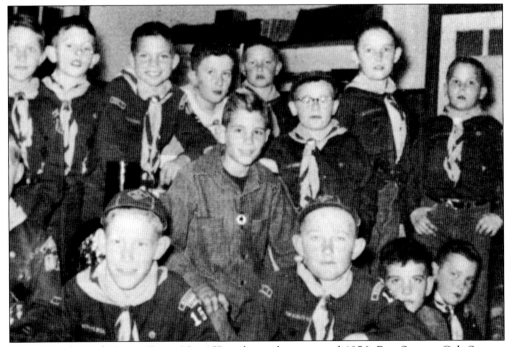

Round Rock's Cub Scout Troop No. 157 is shown here around 1956. Boy Scouts, Cub Scouts, and Girl Scouts in Round Rock all date from the 1940s. This photograph shows boys from the high school class of 1964 when they were young Scouts some eight years before. (Courtesy Round Rock High School.)

Robert Taliaferro delivered the first recorded Baptist sermon in Williamson County in 1846. He became the first pastor of Brushy Creek Baptist Church, which later changed its name to First Baptist Church of Round Rock. The congregation met in a community church in Old Town beginning in 1855, sharing a sanctuary with the Methodists, Cumberland Presbyterians, and Church of Christ. This sanctuary was built in 1897 at Austin and Anderson Streets. The church has been meeting at the same site for more than a century. (Courtesy author's collection.)

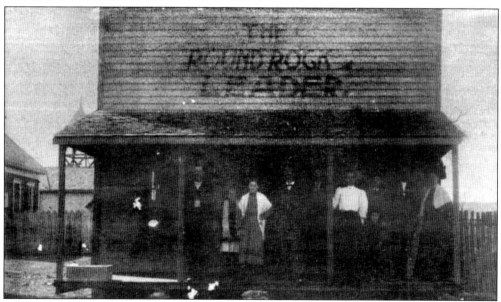

Nat Q. Henderson founded Round Rock's first newspaper, the *Sentinel*, in 1870. Later newspapers included the *Headlight*, *News*, *Weekly Quid Nunc*, *Record*, *Reflector*, *Reporter*, and the *Two Round Rocks*. The *Round Rock Leader* dates back to papers from 1876, although the name first appeared in 1896. The Kavanaugh family published the *Leader* for 43 years, first John H. (1929–1957) and then his daughter May (1957–1972). This undated photograph shows the *Leader* offices in the early 20th century. (Courtesy *Round Rock Leader*.)

Immigrants from Sweden began arriving in Williamson County in 1847, and by the mid-1850s, an enclave in what would be called Palm Valley had formed, holding Lutheran worship services by 1854. Palm Valley Lutheran Church formally organized in 1870, and in 1894, they built their distinctive, redbrick, Gothic Revival sanctuary, with a tall steeple visible for miles. (Courtesy author's collection.)

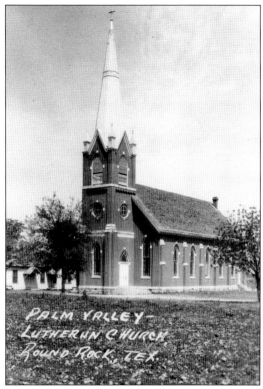

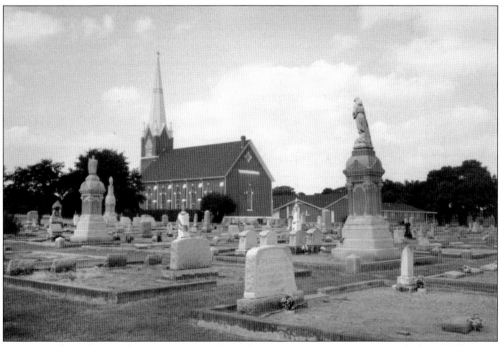

A great influx of Swedish immigrants to Texas began in the 1840s. Many settled in Williamson County. Widow Anna Palm arrived here in 1853 with six sons. Her youngest son, Henning, became the Palm Valley Lutheran Church cemetery's first burial in 1863. (Courtesy author's collection.)

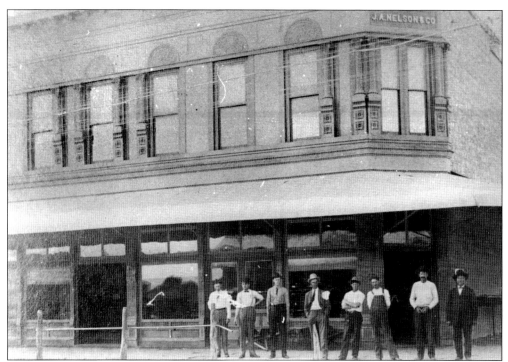

One of the most prominent commercial buildings remains the Nelson Hardware building, whose facade was built in 1900 on an older two-story limestone structure. The Nelson family operated a bank, a hardware store, and other offices inside. (Courtesy Martin Parker.)

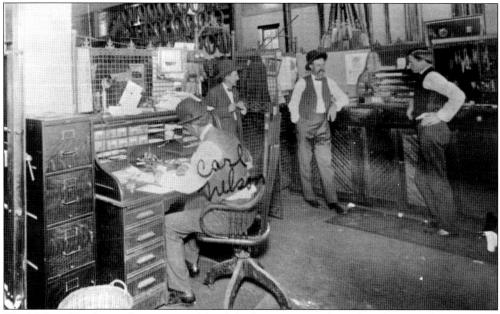

The Nelson Hardware Company and bank built a great number of residences, churches, and commercial buildings in Round Rock around the start of the 20th century. This photograph shows the interior of the bank portion of the Nelson Hardware Building in the 1900s. Carl Nelson is seated at left. (Courtesy Martin Parker.)

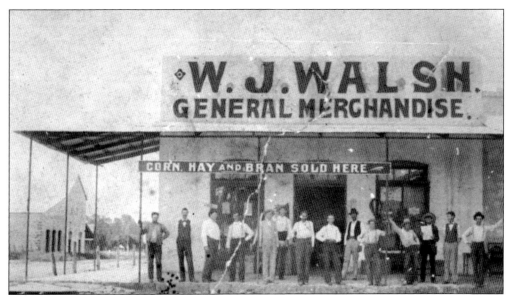

Downtown merchants gather outside W. J. Walsh's general merchandise store on Main Street in this undated photograph. From left to right are unidentified, Martin Moose, Simeon A. Pennington, W. J. Walsh, Archie Hester, Luke Robertson, and the remaining eight unidentified. (Courtesy Martin Parker.)

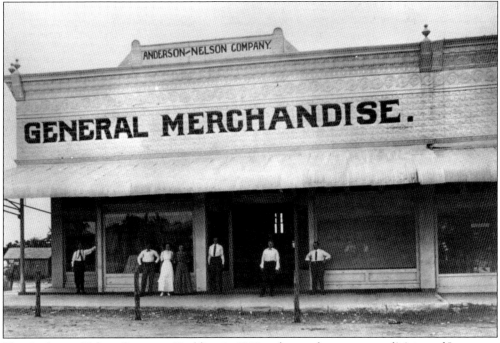

The Anderson-Nelson Company Building in 1910 at the northeast corner of Main and Lampasas Streets over the years has housed several stores and restaurants, including the Mercantile, Tin Horn Charlie's, and Turner's Furniture. The building suffered three major fires in 100 years, but the exterior still looks much the same today as when it was built. (Courtesy Martin Parker.)

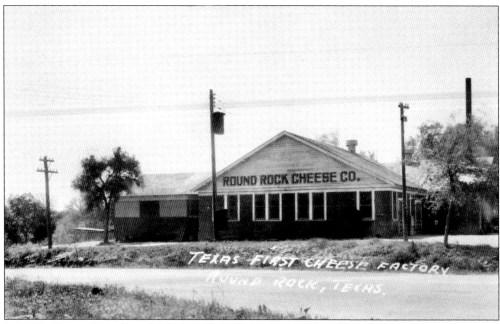

In 1927, Elmer Cottrell and Thomas E. Nelson partnered to form the Round Rock Cheese Company, which became the first successful cheese plant in Texas. They hired August Kaufman from Wisconsin to run the operation, and by the following year, the plant was so successful that Armour and Swift of Fort Worth bought the company. (Courtesy author's collection.)

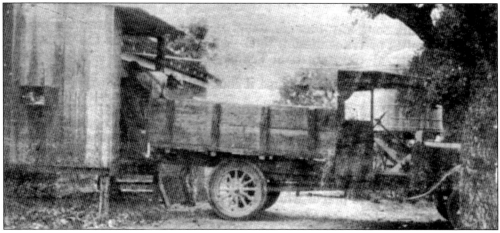

This 1928 photograph from the *Round Rock Leader* shows a milk truck on a weighing platform at the Round Rock Cheese Factory. The factory was established at an opportune time for area farmers, allowing Williamson County farms to survive a boll weevil infestation that decimated cotton crops, a general decline in agricultural prices, and a nationwide economic recession that became the Great Depression. (Courtesy *Round Rock Leader.*)

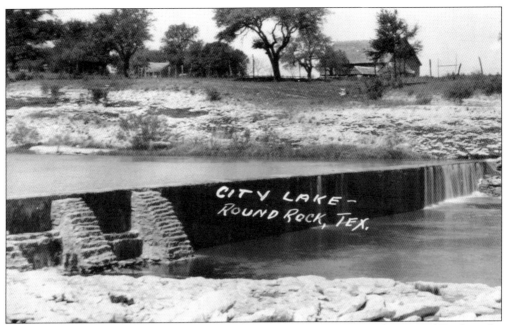

Brushy Creek has been the center of the community since settlers moved to Round Rock in the late 1830s. It has been a landmark, a post office namesake, and a source of power for grist and sawmills. In 1932, the federal Department of Agriculture funded dams on Brushy Creek for flood control and recreation. This 1930s postcard shows the dam built just west of the round rock. (Courtesy author's collection.)

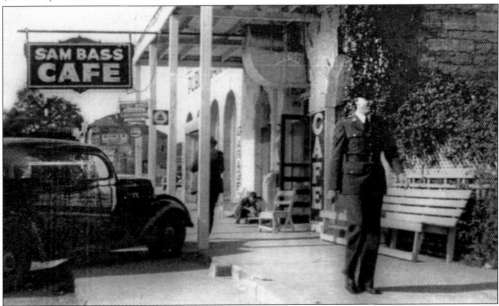

A soldier walks past the Sam Bass Café on Main Street in the 1940s. Over the years, as many as five restaurants in Round Rock have gone by that name, in reference to the bank and train robber who was shot and killed by Texas Rangers here in 1878. The one shown here began in 1926, was run by Bill and Ann Baker, and was famous for its advertised "wingless, neckless, backless fried chicken dinners." (Courtesy City of Round Rock.)

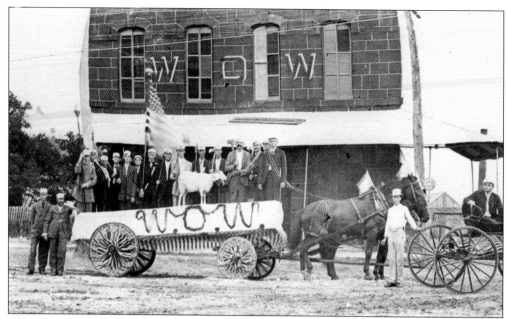

The Woodmen of the World was a popular organization in Round Rock at the start of the 20th century, and their two-story building at the northwest corner of Main and Mays Streets also housed the *Round Rock Leader* on the first floor. The building was razed in 1934 as Mays was widened to accommodate U.S. Highway 81. (Courtesy Martin Parker.)

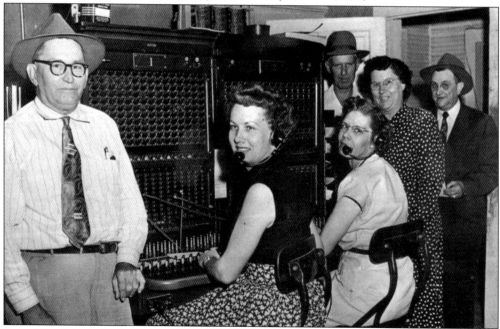

Round Rock had telephone service to Taylor as early as 1883, and for several decades, operators worked a switchboard at an exchange building at Mays and Liberty Streets to connect customers. This photograph from October 27, 1951, shows one last pose around the switchboard before automatic dial equipment was installed. In 1963, new telephone numbers in Round Rock were assigned in the Alpine-5 (255) exchange. (Courtesy Martin Parker.)

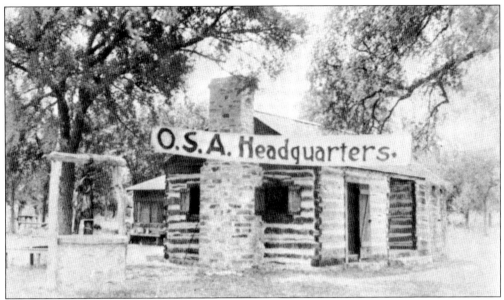

The Old Settlers Association (OSA) grew out of reunions and barbecues of Civil War veterans in Williamson County in the 1880s. The association officially organized in 1904, meeting for its early years at Georgetown's San Gabriel Park until a 1921 flood destroyed the site. After one year in Liberty Hill, the OSA moved to Round Rock in 1923, meeting at Nelson Park north of downtown until the Harrell family donated land for a permanent headquarters between Old and New Round Rock in 1931. (Courtesy Round Rock Chamber of Commerce.)

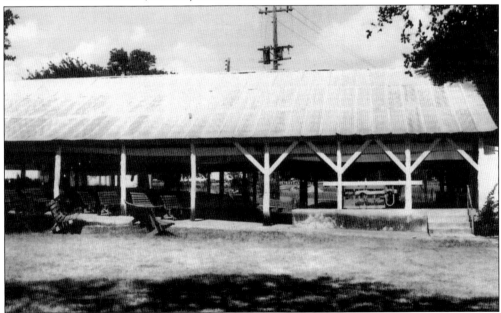

This photograph shows the historic tabernacle at the Old Settlers Association's Harrell Park site. The OSA met here from 1931 until 1988, when the group moved to a new park site on the east side of town along U.S. 79. Although the tabernacle is no longer standing, the OSA moved historic cabins and the Rice's Crossing Store to the site, which also includes the Palm family's 1912 house, barn, and outbuildings. (Courtesy Martin Parker.)

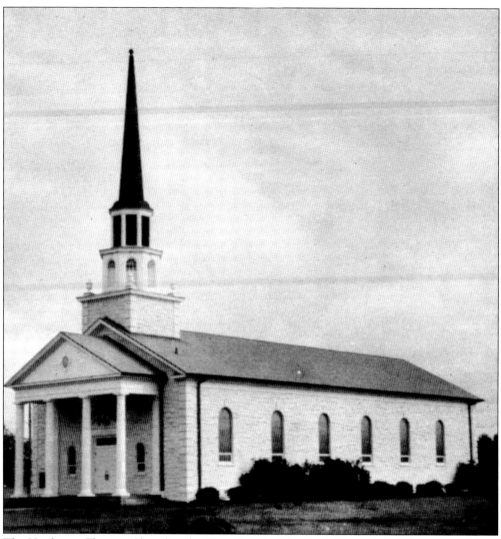

The Hankamer-Fleming Chapel at the Texas Baptist Children's Home (TBCH) is pictured here in 1965, ten years after it was built. Louis and Billie Sue Henna donated 112 acres of land to the Baptist General Convention of Texas in 1950 to create a home for orphans of all religious backgrounds. Construction of the first phase of buildings was completed in a few months, and the home opened in September 1950 with a campus of three children's cottages, an office building, and a superintendent's residence. By 1954, the TBCH had grown large enough that the directors built an elementary school across U.S. 81 to help the Round Rock schools deal with the influx of new students. (Courtesy Round Rock Chamber of Commerce.)

Four

SCHOOL DAYS

Education took root in Round Rock. The Round Rock Academy was founded in 1862, with George Washington Davis, Dudley Snyder, and Thomas Jefferson Caldwell as the founding board members. The school was well known rather quickly, as the state's 10th Legislature took time out from more pressing Civil War–era concerns to pass a law forbidding liquor within four miles of the schoolhouse at Round Rock. At the time, the only other small colleges in the area were at Salado and San Antonio. Education improved again with the founding of the Greenwood Masonic Institute in 1868. This school offered an education to a wide audience in Central Texas, as other schools and universities were fairly distant. Under the able leadership of Capt. J. D. Morrison and later S. G. Sanders, the institute assembled a prestigious faculty, including Horace Landrum, Frank Vickery, and noted music teachers David Switzer and his wife, Rebecca, formerly Rebecca Mays of Round Rock. The Greenwood Masonic Institute was the first college-level school in the county, with classes ranging from chemistry and metaphysics, to bookkeeping and Greek.

The railroad also improved education. After the International and Great Northern arrived in 1876, there were up to a dozen schools in Old and New Town, including Round Rock College, and several schools for African American students offered through area churches. The Round Rock Institute became a public high school in 1888. In the 1890s, Round Rock citizens voted 113-18 to assess themselves double the standard property tax (20¢ per $100 valuation) to benefit local schools. A 1906 vote to organize an independent school district failed, but another vote in 1913 passed. The independent school district movement had taken hold, and Round Rock citizens took a more active role in the daily operation of the public schools.

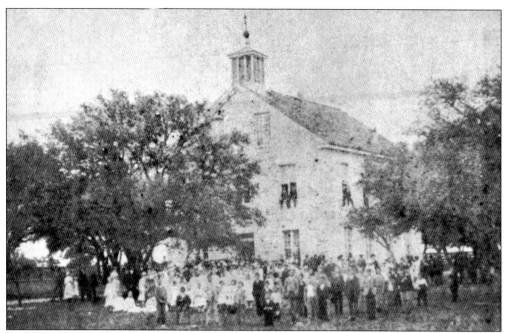

Round Rock's Masonic Lodge No. 227 organized in the 1850s with the assistance of the lodge at Georgetown. The Round Rock lodge established the Greenwood Masonic Institute in 1868 near Brushy Creek. The school offered college-level courses as well as more basic education. (Courtesy Round Rock High School.)

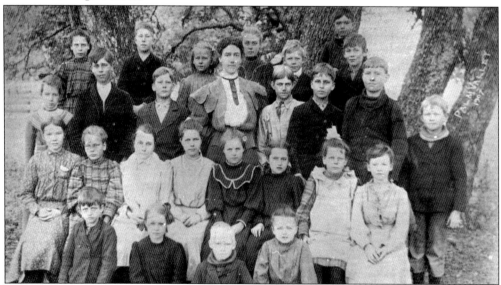

A photograph of the Palm Valley rural school in 1907, one of several that consolidated with Round Rock in the 20th century, includes, from left to right, (first row) Oscar Warner, Agnes Quick, Walter Noren, and Jessie Dabs; (second row) Annie Peterson, Enna Johnson, Margaret Palm, Signe Quick, Alma Quick, Ebba Quick, Elsie Johnson, and Edith Burklund; (third row) Lillie Johnson, Eric Swenson, Oscar Beck, Tilda Palm (teacher), Louise Johnson, Hugo Swenson, Jack Anderson, and Oscar Burk; (fourth row) Bertha Johnson, Nels Swenson, Ellen Noren, Nora Pokrant, James Harris, George Harris, and Don Dabs. (Courtesy Martin Parker.)

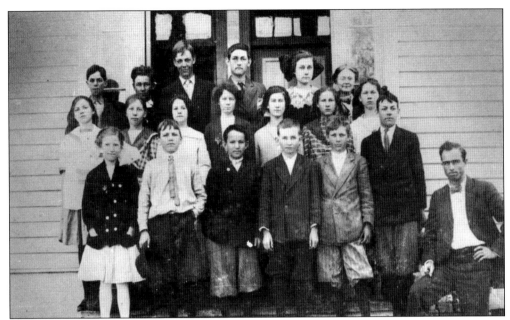

This *c.* 1910 photograph shows students at Round Rock High School. From left to right are (first row) Lorraine Voigt, Oscar Stewart, George Stone, Paul Landrum, Ralph Johns, Robert Egger, and Professor ? Webb; (second row) Nettie Bradley, Elvira Pearson, Ruth Stone, Emma Johnson, unidentified, Lola Taylor, and Clara Daniels; (third row) Arthur "Peaches" Ferrell, Paul Pokrant, unidentified, Carl Wright, Margaret Palm, and Ida Robertson. (Courtesy Martin Parker.)

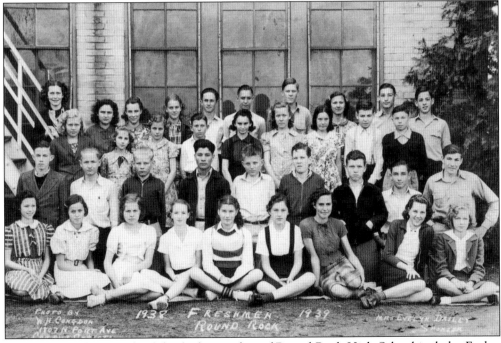

A 1938–1939 photograph of the freshman class of Round Rock High School includes Evelyn Dailey, class sponsor, at upper left. School went to 10 grades until 1919, when an 11th grade was added, and extended again to 12 grades in 1942. (Courtesy author's collection.)

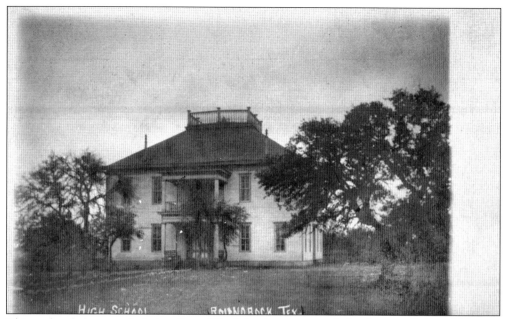

This undated photograph depicts Round Rock Institute on top of what became College Hill, now the northwest corner of Interstate 35 and 620. The institute followed the Greenwood Masonic Institute as a combined public school and college. (Courtesy author's collection.)

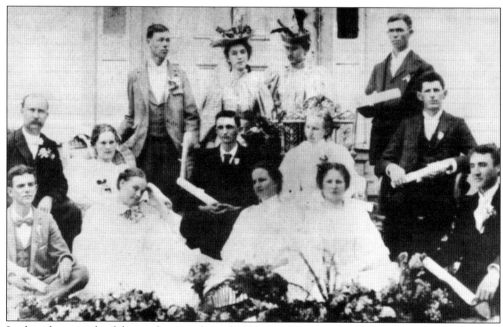

In this photograph of the graduating class of 1894, Sam Kemp, a future lawyer, county judge, and territorial chief justice, is seated at far right of the second row. His future wife, May Hope, is second from the right on the first row. Kemp was a justice of the Territorial Supreme Court of Hawaii for 26 years, including chief justice from 1941 to 1960. Kemp signed the order transferring court authority to martial law on December 8, 1941, following the Japanese attack on Pearl Harbor. (Courtesy Martin Parker.)

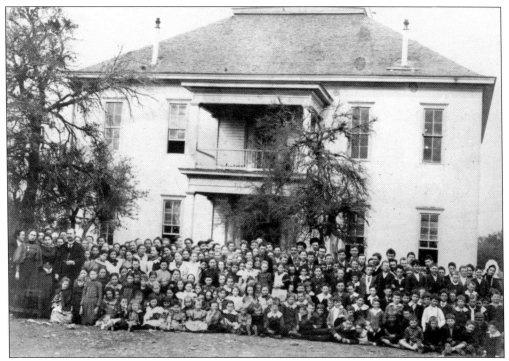

An 1890 photograph shows the students of the Round Rock Institute. One notable student who attended school about this time was Andrew Moses, a native of Burnet County who took classes at the institute before furthering his studies at the University of Texas and later graduating from West Point. Moses was commandant of cadets at Texas A&M from 1907 to 1911, helping train several high-ranking officers of both world wars. (Courtesy Martin Parker.)

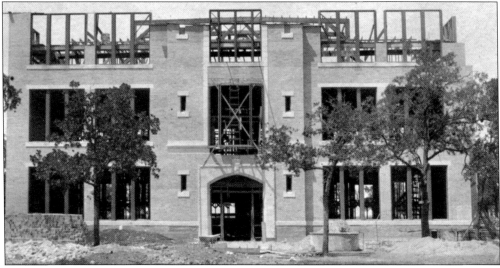

Citizens voted to create an independent school district in May 1913, one month after the wooden high school burned. Residents of Williamson County Common School District No. 19 voted 55-2 in favor of incorporating as the Round Rock Independent School District. A new three-story brick building took one year to complete and was dedicated in March 1914 with a barbecue and outdoor basketball games. (Courtesy Martin Parker.)

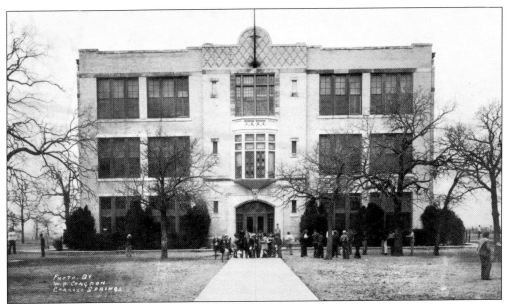

Houston architect Ollie J. Lorehn designed the 1914 Round Rock High School. The first and second floors contained five rooms each, while the third floor had music and art rooms, and a large auditorium with a stage and dressing rooms. A cement sidewalk surrounded the 4-acre campus. That fall, the number of grades taught was raised from 10 to 11. In 1942, a new wing was built for the high school, and the three-story building was used for junior high and elementary grades. By 1962, the school building was torn down. (Courtesy author's collection.)

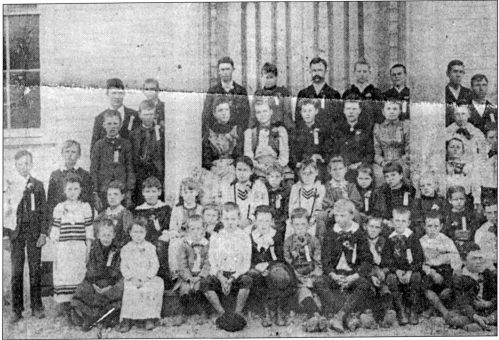

This photograph shows students at the Round Rock Institute in the 1890s. Notable teachers of the time included A. S. J. Steele, a longtime principal, and David and Rebecca (Mays) Switzer, who later established colleges in Itasca, Dallas, and Weatherford. (Courtesy *Round Rock Leader*.)

Management of the Greenwood Masonic Institute, founded in 1868, transferred in 1884 from Round Rock's Masonic Lodge No. 227 to the Southern Presbyterian Church. The school was a combination public-tuition venture, with free high school work and tuition charged for the college courses. The arrival of the railroad in 1876 and the ensuing population growth also resulted in new schools, including Prof. I. N. Stephens's Round Rock Academy and African American schools taught through local churches. An October 22, 1886, newspaper advertisement lists the many amenities of the Round Rock Institute. (Courtesy *Round Rock News*.)

Round Rock Institute

A CLASSICAL HIGH SCHOOL

◀FOR▶

MALES AND FEMALES.

Next Session Opens Monday, Sept. 13, '86.

—O—

REV. C. H. DOBBS,
Principal.

MISS LILLIS KNOX,
Assistant.

A. L. BONDURANT,
Prof. Latin, Greek and French.

MISS S. B. MORRISON,
Principal Primary Department.

MISS WADE S. BLAKELY,
Instructor in Music.

MISS BETTIE WASHAM,
Teacher in Art.

—O—

A Commercial Course has been arranged, embracing Book Keeping, Commercial Law and the practical forms of Business.

Latin, Greek, Spanish, French and German languages taught.

Thorough drill in all the Rudiments a Specialty.

It shall be our aim to make school life pleasant and attractive. To inspire the pupils with love for study. To this end all modern appliances have been introduced. The School is now furnished with a supply of excellent Maps, Globe, Blackboards, Charts, Arithmetical and Geometrical Blocks, etc., etc.

Round Rock is justly noted for its health. The citizens are liberal, moral and intelligent. All the Evangelical denominations hold regular services in the town.

Special arrangements have been made for boarding pupils in the homes of the best families of the place at the reasonable rate of $3.00 (three) dollars per week, including fuel and lights. The entire cost for the year need not exceed $160 for ordinary course in English and Ancient languages.

For further particulars or catalogue address the Principal.

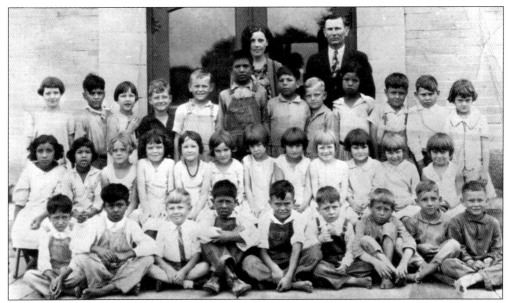

Here is a photograph of Round Rock High School's first-grade class in 1929. From left to right are (first row) two unidentified, Warren Kaufman, unidentified, Alton Prewitt, Edward Stark, Glen Warren, Johnnie Schmitt, and Milton Krienke; (second row) two unidentified, Artie Louise Ferrell, Gladys Youngbloom, Lillianette McNeese, Velda Ruth Hill, Emma Jean Hamilton, Katharine Brown, Maudie Fields, Dorothy Mae Whitely, Gladys Anderson, and Mary Sansom; (third row) Tony Schmidt, Isaac Perez, Louise Stobaugh, Luther Ross, two unidentified, Enos Martinez, George Woolsey, unidentified, Frank McNeese, Billy Sellstrom, and Bessie Hester; (fourth row) Xenia Voigt (teacher) and P. E. Dickinson (superintendent). (Courtesy Martin Parker.)

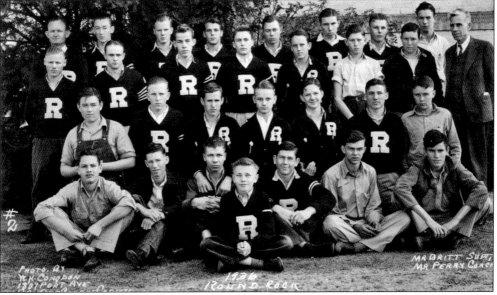

The 1936 Dragons were the first team in school history to go undefeated, racking up a 9-0 season record and winning the district title. Five of the games were shutouts, and they allowed six points each to the other four opponents. Jack McCann led all scorers. O. F. Perry, then the principal, was also the head coach. (Courtesy author's collection.)

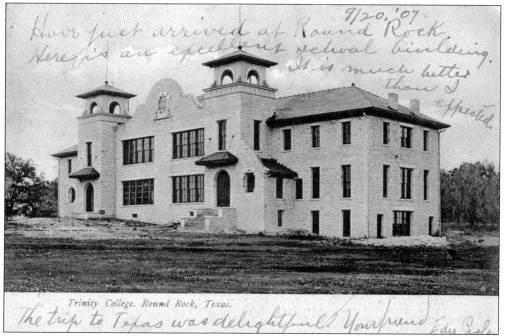

Trinity College. Round Rock, Texas.

In 1904, the Augusta Lutheran Synod Conference met in Kansas and approved a proposal to locate a college in Texas. Through John A. Nelson, Round Rock offered a cash bonus of $7,000, four city lots, and a water well if the school were located there. Later discount rail shipping and further property totaling 10 acres were added to the bid. At a meeting in Austin in early 1905, the Round Rock bid was accepted unanimously, and work began immediately. Architect C. H. Page of Austin was selected to design the structure, and the Evangelical Lutheran Trinity College of Round Rock, Texas, was incorporated. The school opened in October 1906 with an enrollment of 96 students and 4 teachers. (Courtesy author's collection.)

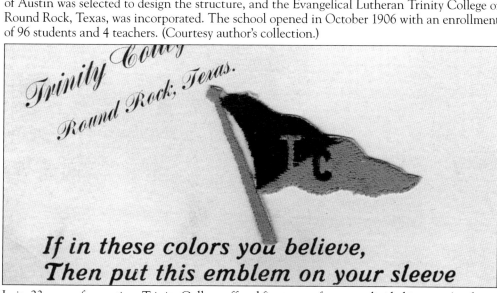

**If in these colors you believe,
Then put this emblem on your sleeve**

In its 23 years of operation, Trinity College offered five years of courses, divided into an Academy, a School of Business, and a School of Music. Student activities included literary and musical societies, and an athletic association. Trinity fielded teams in basketball, baseball, tennis, and even football. Trinity achieved state accreditation in 1926, becoming a state-approved junior college. (Courtesy author's collection.)

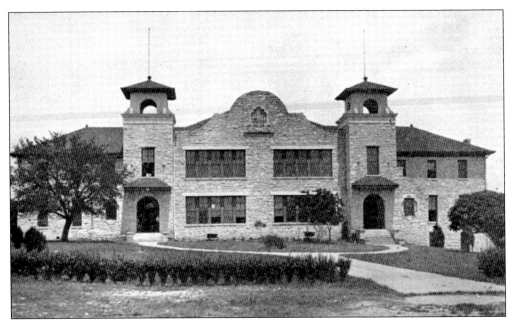

Trinity's presidents were Dr. J. A. Stamline, Alfred Anderson, Theodore Seashore, Oscar Nelson, and Harry Alden. The President's House still stands south of Main Street. Trinity achieved state accreditation in 1926, becoming a state-approved junior college. But Trinity's enrollment and funding was always lower than was hoped for, and the school closed in 1929 and consolidated with Texas Lutheran College in Seguin. (Courtesy Trinity College's 1919 yearbook, *The Round Rock*.)

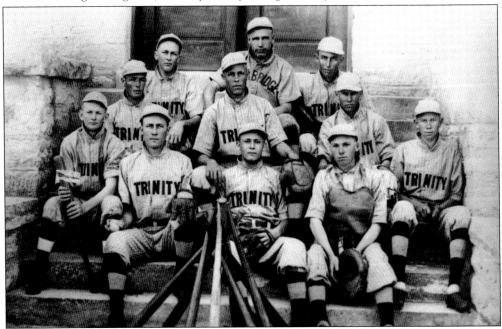

A photograph of Trinity's 1916 baseball team includes, from left to right, (first row) Art Lind, Bud "Oliver" Carlson, and Willie Parker; (second row) Robert Westberg, Oscar Lundelius, Reuben Gustafson, Gunnar Jacobson, and John Anderson; (third row) Helmer Johnson, N. O. Hultgren, and Truett Archer. (Courtesy Martin Parker.)

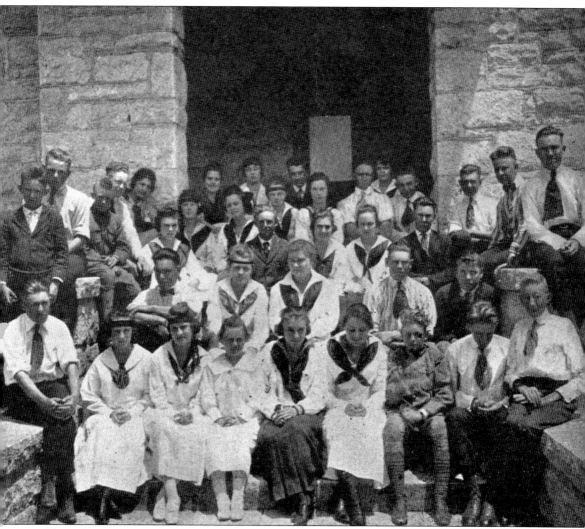

The Whittier Literary Society at Trinity College is shown here in 1919. Other organizations and activities at Trinity that year included commercial, business, music, and domestic art departments, girls' chorus, male chorus, baseball, and tennis. Many of the students were first- or second-generation Swedish immigrants from around Texas, Illinois, Kansas, and other states. In 1929, Trinity merged with the Lutheran school from Brenham and became Trinity Lutheran College at Seguin. The Round Rock campus became a home for orphans and the aged. The main three-story college building developed structural problems and was torn down, with the stones used in new buildings on the campus. (Courtesy Trinity College's 1919 yearbook, *The Round Rock*.)

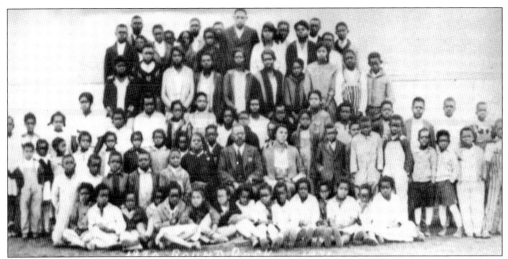

The Hopewell School for Round Rock's African American children dates from before 1900. In 1922, school trustees built a new schoolhouse with the help of a grant from the Rosenwald Foundation of Chicago, which built more than 500 schools in Texas to improve African American education. Hopewell and Round Rock schools integrated in 1966. The Hopewell School was later moved and rebuilt, and is now a community center at the Round Rock Independent School District offices. (Courtesy Round Rock Independent School District.)

Stony Point rural school was established east of Round Rock by 1891 on the Noack Ranch. In 1894, Stony Point had 63 students, more than nearby rural schools such as Gattis (46), Bell (38), and Palm Valley (37). J. B. Chapman was the sole teacher that year for all those pupils. This schoolhouse was built about 1906 and operated until Stony Point consolidated with Round Rock in 1942. Stony Point High School opened in 1999 a few miles west of the original Stony Point. (Courtesy Texas Historical Commission.)

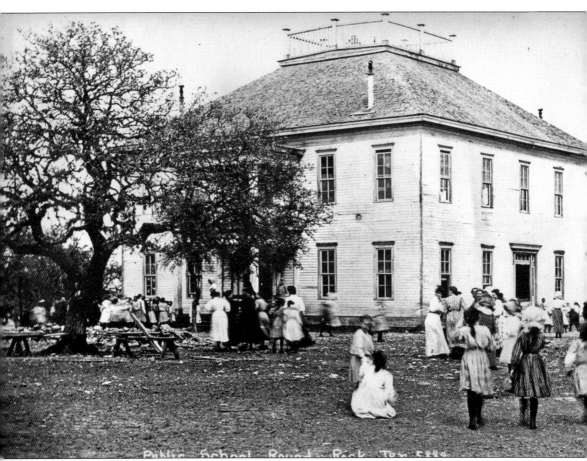

This photograph shows Round Rock High School and its students around 1905. M. A. Toole was the principal at the time. The two-story schoolhouse was built on College Hill between Old Round Rock and New Round Rock. The location is now the northwest corner of Interstate 35 and 620. The schoolhouse was built in 1884 as the Round Rock Institute and was destroyed in a 1914 fire. Later the Round Rock school board commissioned a stone schoolhouse for Mexican American children to be built at the same site; it was active from 1931 to 1945. (Courtesy City of Round Rock.)

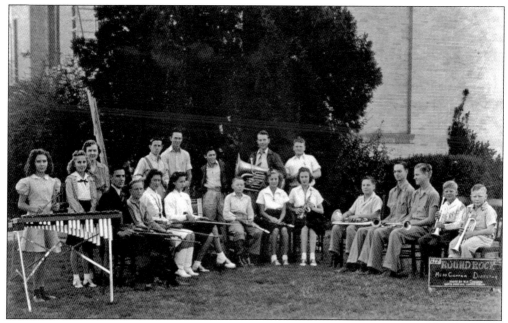

Round Rock High School's first band is pictured during the 1940–1941 school year. A Ms. Curran was the first band director. In January 1985, the Round Rock High School Marching Band received widespread notice when they marched in the Tournament of Roses Parade in Pasadena, California, on national television. (Courtesy Martin Parker.)

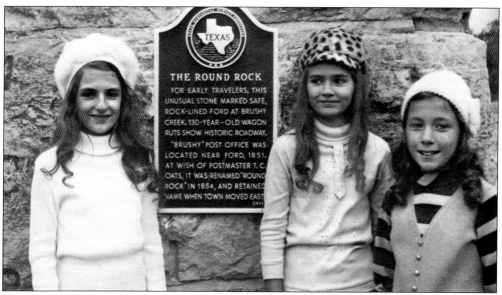

From left to right, Gena Kathryn Antill, Bernice Anne Antill, and Johnette Ledbetter pose next to the round rock on the day its official Texas Historical Marker was unveiled in November 1971. Round Rock and Stony Point High Schools have both had active Junior Historian programs to interest young people in their history. (Courtesy Martin Parker.)

Five

WORK AND PLAY

The railroad brought more than goods and services to Round Rock. It made it a more cosmopolitan town, as people came from all over the country and around the world to realize their vision of the American dream. Farming was still the major economic activity in the land around town. But in the city, one could find the confectioner from Italy, the wheelwright from Prussia, the stonemason from England, the doctor from Pennsylvania, and the blacksmith from Norway. For local and global news, people could turn to multiple newspapers.

In the 1880s, the Round Rock–to–Georgetown phone connection cost 7¢ a minute. Beyond family and work, residents could join social clubs, such as the Woodmen of the World, the Knights of Pythias, and the International Order of Odd Fellows. The fire department, which had its origins in a downtown fire in 1879, was augmented by the founding of multiple hook-and-ladder companies in 1889. All of these groups had frequent barbecues, festivals, and gatherings to promote community spirit. For good clean fun, there was the ice cream social where the boys provided lemonade and tried their hand at sewing for prizes.

The major economic change was the widespread planting of cotton as a cash crop. The fertile Blackland soil of Williamson County and good rainfall were a perfect combination for the development of a major cotton industry. Within a few years of its founding, Taylor became the largest inland cotton port in the world. Williamson County was frequently the top-producing cotton county in the United States. Every town had a gin, and Round Rock had three at one time downtown by the railroad depot. "First Bale" was a bonus offered by local businesses to the first farmer to bring a bale of cotton to town to kick off the harvesting season in late summer. Very quickly, cotton became king.

For generations in Williamson County, cotton drove the economy. Cotton growing can be traced back to the 1850s, but it was not an economically viable crop until many years later. Round Rock built cotton gins soon after the railroad arrived; a December 1876 *Burnet Bulletin* article relates, "Mr. Henry Koppel, of Round Rock, purchased the first four bales of cotton brought to that place from Fort Concho." In October 1897, a Williamson County Cotton Grower's Union organized, and Round Rock postmaster Robert Hyland received a U.S. patent for a cotton chopper. In several seasons around the turn of the 20th century, Williamson County was first in the state in baled cotton and once was even the top county in the nation. The arrival of the boll weevil and improved irrigation in West Texas in the 1920s reduced the crop's importance to the local economy. (Courtesy author's collection.)

To process cotton from the fields, the Farmers Union Gin and Planters Gin in downtown Round Rock operated near the railroad tracks for many years. The Planters Gin was located just south of the Nelson Hardware Company along Bagdad Street, and the Farmers Union Gin was a few blocks southwest between the tracks and Lake Creek. (Courtesy Round Rock Chamber of Commerce.)

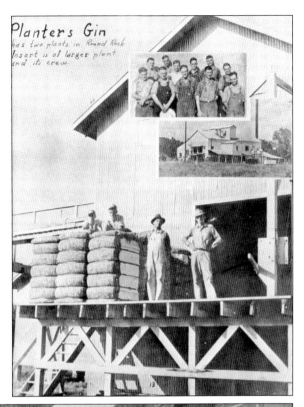

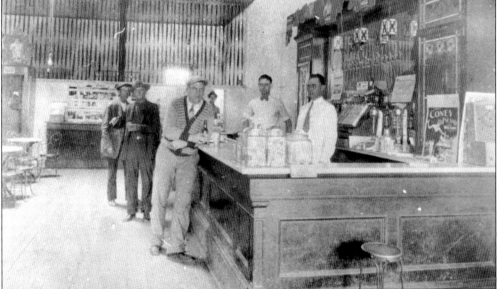

Giuseppe Montedonico, a confectioner from Italy, commissioned a new building at 119 East Main Street in 1881, and he opened a fruit and candy store there. Over the years, the building also housed a barbershop, rented rooms, and a harness shop. In the 1920s, a popular ice cream parlor named the Alcove was housed here. This c. 1930 photograph shows, from left to right, Lee McDonald, Bob Carlson, Ansel Nelson, Morris Ledbetter, and J. W. Ledbetter. The man in the far back is unidentified. (Courtesy Martin Parker.)

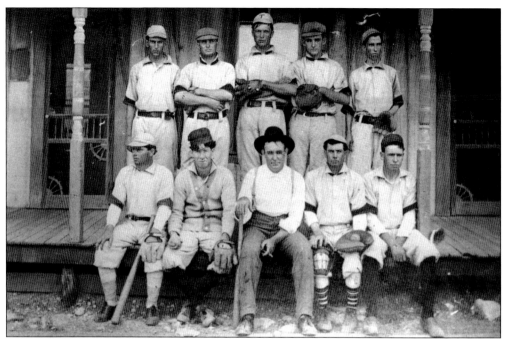

At the dawn of the 20th century, most towns and villages in Williamson County had town baseball teams before the sport was popular through high schools. This 1911 photograph of the Round Rock town team includes, from left to right, (seated) W. A. Trusdel, Posey Awalt, Jack Jordan, John Trusdel, and Bert Fouse; (standing) Curtis Parker, Leslie Parker, Merrell Jester, Lloyd Landrum, and Gill Foyil. (Courtesy Martin Parker.)

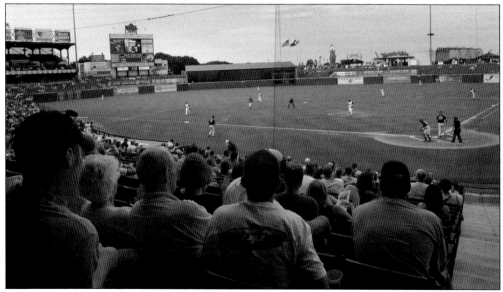

Baseball has continued in popularity here. Round Rock and Westwood High Schools have been particularly successful, sending multiple teams to the state tournament. In 2000, partners including Hall of Fame member Nolan Ryan brought minor league baseball's Round Rock Express to town. The Houston Astros affiliate, first AA and now AAA, plays at Dell Diamond. (Courtesy Texas Department of Transportation.)

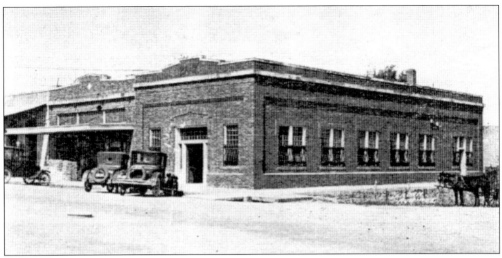

Thomas E. Nelson worked in Washington, D.C., as a secretary to Congressman James Buchanan, then returned to Round Rock and had many successful business interests. He was president of Farmers State Bank, which opened in August 1920, for 20 years. (Courtesy *Lloyds Magazine*, 1928, issue unknown, in files at Round Rock Public Library.)

The J. A. Nelson building housed a hardware and implements store, as well as a private bank owned and operated by the Nelson family. The Nelsons founded the bank in about 1900. This photograph shows bank teller Gus Lundelius at left and Carl Nelson in the doorway in 1913. (Courtesy Martin Parker.)

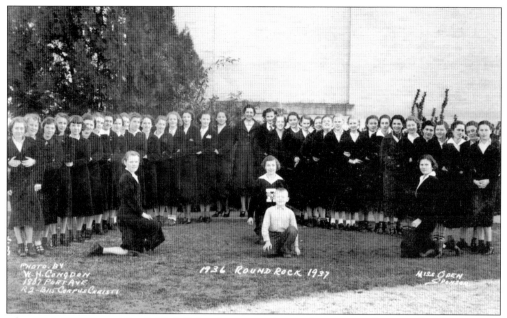

The 1936–1937 Round Rock High School pep squad poses for a group photograph. The sponsor, a Ms. Oden, stands at the center of the line. This was one of the earliest years for the group that would be later called the Dragonettes. The girl kneeling at front center has a varsity "R" sweater with tennis rackets, signifying one of the sports available to girls at the time, along with basketball and volleyball. (Courtesy author's collection.)

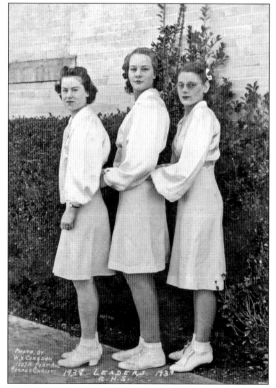

From left to right, Marjorie Johnson, Dorothy Collier, and Lillianette McNeese, cheerleaders for Round Rock High School in 1938–1939, pose for a photograph between the football field and the school on Anderson Avenue. Arvilla McVey was the sponsor of the cheerleaders and pep squad from 1937 to 1940. (Courtesy author's collection.)

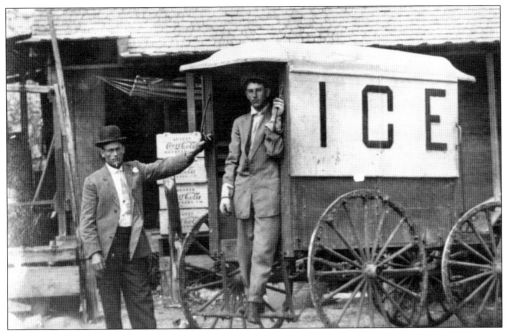

This *c.* 1913 photograph shows H. N. Egger (left) and Curtis Parker with an ice delivery wagon. In the days before electric refrigeration, homes and businesses relied on the ice man to keep food from spoiling. Egger also operated the Round Rock Bottling Works, which produced glass bottles stamped with Round Rock's name for distributing beverages. (Courtesy Martin Parker.)

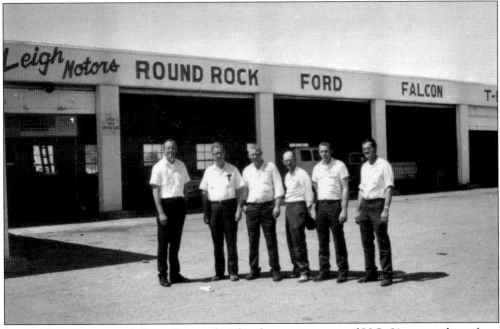

Leigh Motors was on a hill on the south side of town, just east of U.S. 81 approaching from Austin. Mack and H. R. Leigh were the owners. This 1972 photograph shows, from left to right, Charles Gresham, Charles Watt, Don Hoyle, Ernest Johnson, Ralph Granzin, and L. Klepac. (Courtesy Martin Parker.)

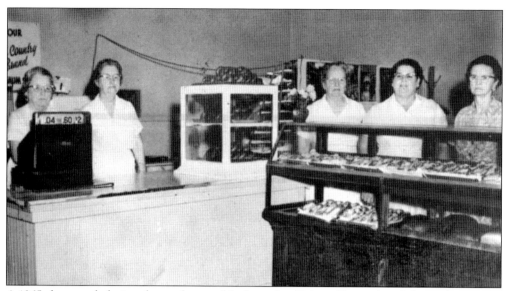

A 1965 photograph depicts the employees of the Lone Star Bakery. Shown from left to right are Rosa Almquist, owner Mrs. Ernest Johnson, Mrs. Eric Moberg, Mrs. Walter Kaatz, and Ellen Johnson. The Lone Star Bakery, established in 1926, has moved its facilities but has always remained in downtown Round Rock. (Courtesy Round Rock Chamber of Commerce.)

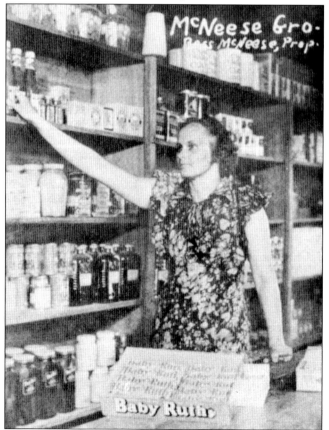

Bess McNeese, proprietor of McNeese Grocery, is shown in a 1938 photograph. McNeese continued a tradition not only of downtown grocery stores, but also of female business owners. Adelheid Dieckmann owned and operated a store from 1881 to 1889 at 108 East Main Street. (Courtesy Round Rock Chamber of Commerce.)

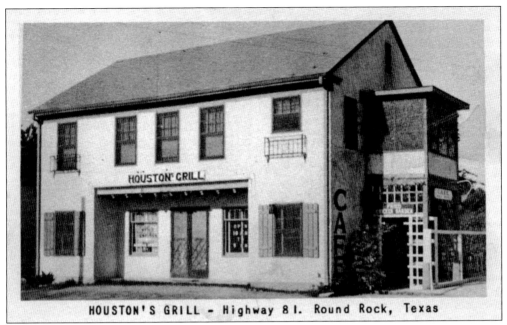

HOUSTON'S GRILL - Highway 81. Round Rock, Texas

In 1936, Mr. and Mrs. Sam Sowell opened the S&S Grill on Mays Street just south of Main Street. They sold the business in 1947 to Ira Houston, who operated Houston's Grill for three years. Gay's Restaurant, Loep's Longhorn Restaurant, and Chapa's Barbecue continued the building's restaurant tradition through the 1960s. (Courtesy author's collection.)

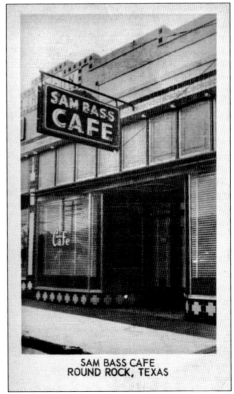

SAM BASS CAFE
ROUND ROCK, TEXAS

J. C. Jackson began a furniture store in Round Rock in 1897 and moved to 108–110 East Main Street by 1909. In 1931, he commissioned a new art deco facade for the building. The Sam Bass Café, E. H. Johnson's feed and paint store, and White's Auto operated here for many years. (Courtesy author's collection.)

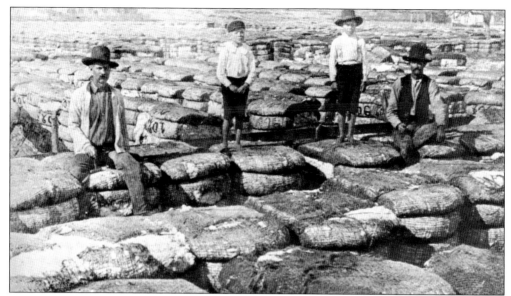

Around the end of the 19th century, the area from Austin Avenue north to Brushy Creek was filled each fall with sacks of cotton, baled at the downtown gins and awaiting shipment by train or wagon. This *c.* 1900 photograph shows (from left to right) J. M. Jester, Merrell Jester, Johnnie Jester, and Charlie Cochran sitting among 8,000 cotton bales in an area known as the Flat. (Courtesy Martin Parker.)

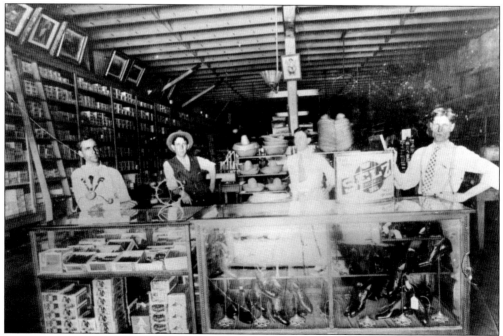

This 1907 photograph shows the inside of the W. J. Walsh store on Main Street. Walsh owned the Round Rock White Lime Company, and this store was both the company store, where employees could get goods on credit, and a general merchandise store open to the public. Shown from left to right are W. J. Walsh, Jim Sharp, O. M. Stanley, and H. L. Stockbridge. (Courtesy Martin Parker.)

This 1912 photograph is captioned, " 'Baby' Harvey at the recreation area at the dam in Old Town. The area had a bathhouse, refreshments and was lighted with electric lights." Brushy Creek has been a source of power for mills and water for drinking, fishing, and swimming for many years. (Courtesy Martin Parker.)

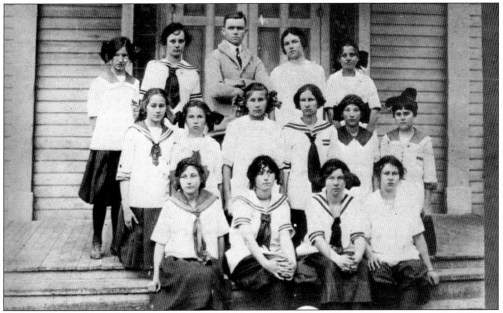

In 1914, the Round Rock High School girls' basketball team won the county championship. Shown from left to right are (first row) Jewell Sanders, Thelma Gage, Clara Daniels, and Stella Baker; (second row) Eva Mae Ledbetter, Vera Jester, Gertrude Ganzert, Lola Taylor, Violet Sanders, and Edra Anderson; (third row) Lorraine Voigt, Katie Studer, coach and principal Thomas Ferguson, Nettie Bradley, and Lou Pennington. (Courtesy Martin Parker.)

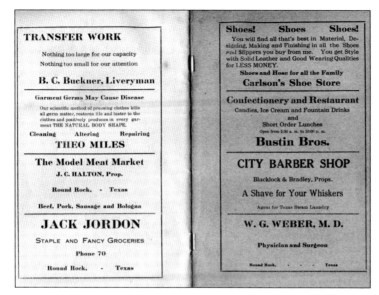

By the early 20th century, Round Rock's commercial district housed a variety of businesses and services. Grocery and dry-goods stores were especially popular, but even in a town of less than 1,000, citizens could partake of a variety of commercial enterprises. The advertisements shown here are from the 1916–1917 annual bulletin for Round Rock High School. (Courtesy author's collection.)

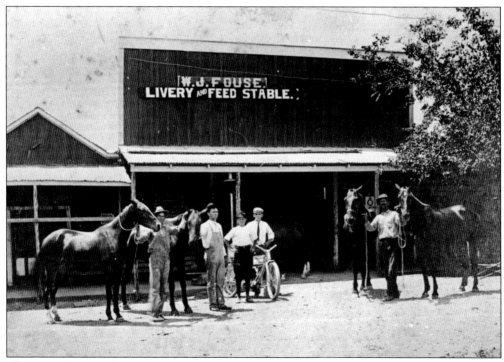

This 1911 photograph depicts W. J. Fouse's livery and feed stable, a vital turn-of-the-20th-century business on West Main Street. Standing from left to right are Henry Pards, William Jeff Fouse, Dewey Bradford, unidentified, and Bud Grumbles. Mississippi-native Fouse came to Round Rock in 1900 and married Susie Jester. He worked a variety of jobs, including hauling wood, working at the broom factory and on railroad teams, selling real estate and insurance, and serving as a trustee of Stony Point School. (Courtesy Martin Parker.)

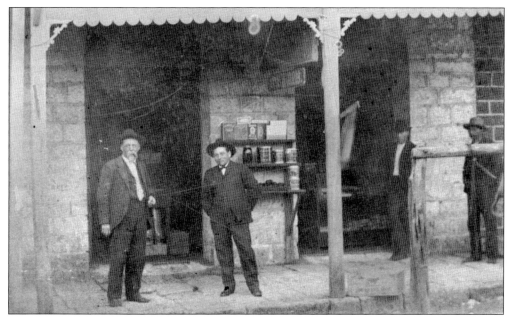

This c. 1910 photograph shows unidentified merchants posing in front of a grocery store. Downtown businesses at the time included Cornelius Gonzales's restaurant (which also sold candy, soda water, cider, cigars, and tobacco); Gantt and McBride's Brooklyn Meat Market; photographer G. W. Ireland; L. Peterson horseshoeing; and Dr. J. H. Johnson and Son's El Merito Pharmacy. (Courtesy Martin Parker.)

In June 1906, the *Williamson County Sun* announced that Round Rock's S. A. Pennington was opening a skating rink in Round Rock. This postcard, postmarked in 1907, shows citizens gathered outside the new and novel attraction. Records indicate the rink was only open for a short time. (Courtesy author's collection.)

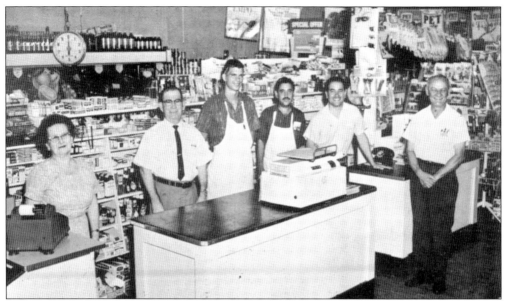

In 1886, Eustis P. Robinson built a structure at 117 East Main Street housing a hardware and stove store. From 1901 to the 1930s, W. J. Walsh operated the Fair at this location. From 1946 to 1971, Rudolph Pettersen operated a grocery store and market. This 1965 photograph shows, from left to right, Annie Bustin, Elmer Hester, Sherrod Prewitt, Edward Gaitan, Pete Camacho, and Rudolph Pettersen. (Courtesy Round Rock Chamber of Commerce.)

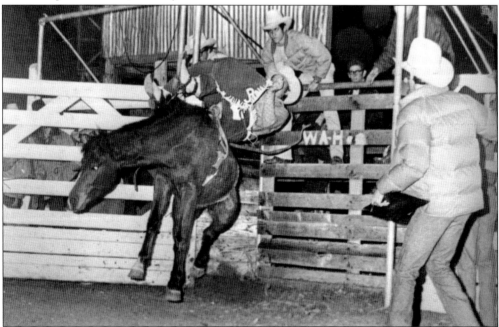

Rodeo events have traditionally been a popular pastime. At the Rough Riders Reunion in Oklahoma City, Oklahoma, in July 1900, Round Rock's J. E. Merrell won first prize for cattle roping. His time was 51.5 seconds. This photograph shows John Reed at the Dripping Springs Rodeo, which was held in Dripping Springs, Texas, on his way to the all-around championship in 1972. (Courtesy Martin Parker.)

John Kavanaugh moved his family from Lometa to Round Rock in 1929 to take the job as editor of the *Round Rock Leader*. He and his family produced the newspaper for the next 43 years. His daughter May, pictured here, became editor and publisher after her father's death. (Courtesy Round Rock Chamber of Commerce.)

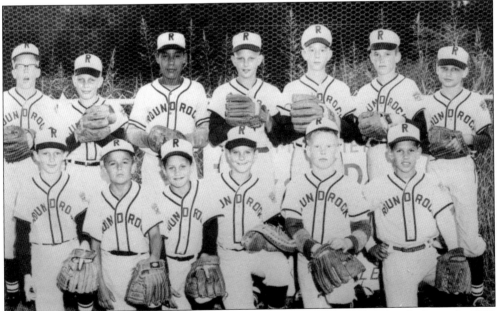

Fred Coffe organized the town's first Little League team in 1951. This photograph shows the 1963 team, coached by Charles Nelson. Shown from left to right are (first row) Glenn King, Leonard Campbell, Wayne King, Johnny Hood, Bruce Burleson, and Tommie Payne; (second row) Scott Whitlow, Alan Wiley, Steve Gonzales, Larry Madsen, Ronnie Woytek, Skipper Parker, and Paul Vernon. (Courtesy Martin Parker.)

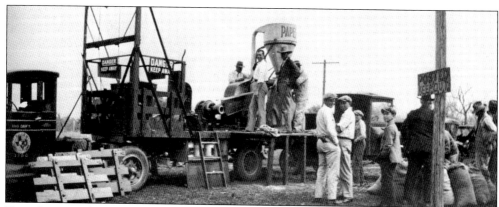

This June 1, 1880, postcard from Round Rock merchant Massena Wiess to his family in Beaumont reads: "Dear Sir, What can you do with oats in car loads F.O.B at 28 to 30 cts sacked. Will cost you 41 to 43 cts laid in B–McFaddin. Mrs. MW will take part—and you might sell some to Craig & Carlisle. Alls well. Your Bro, M. Wiess." (Courtesy author's collection.)

Texas Power and Light (TP&L) became Round Rock's primary electricity provider in September 1927. Electricity promised convenience and efficiency for labor-intensive farm tasks. In this photograph, TP&L demonstrates feed grinding with an electric motor to Round Rock farmers in 1929. (Courtesy Martin Parker.)

Six

TRADITIONS

As a new century neared, a progressive movement seemed to drive decisions. The county spent money to improve roads and construct iron bridges over the major rivers and creeks, including over Brushy Creek at the round rock. The city constructed an artesian well to provide public water, topped with a gazebo as a central point for community gatherings. A new paper, the *Searchlight*, began in 1896 and soon changed its name to the *Leader*. There were public debates, tent revivals, educational seminars, literary societies, grand balls, picnics, and all manner of activities to enrich and enlighten. Georgetown even had a bicycle club. In 1890, Round Rock's population, which had dipped since the boom days of the railroad, was back up to 1,438.

What really got Round Rock noticed was the establishment of Trinity College, a Lutheran school offering higher education courses and practical work in such fields as music, bookkeeping, and business training. The cornerstone ceremony in 1905 drew a large crowd, and by the next fall, the college was open to students. In its heyday, the school even fielded football and baseball teams, and had its own college cheers. Trinity Lutheran, which later became an orphanage and nursing home, has been part of the community for more than a century.

The effort to push Round Rock onward toward the future continued in the 1920s. State Highway 2, connecting San Antonio, Austin, and Dallas, was built through Round Rock and Georgetown rather than Pflugerville and Taylor, increasing visitor and traveler traffic. The chamber of commerce was formed in 1926 to boost local business. In the same year, one of Round Rock's most famous institutions, the Lone Star Bakery, began churning out Round Rock Donuts. Electricity came to town, and the local power plant became part of Texas Power and Light by 1927. The town was still progressing, even as the population fell back to 900 people.

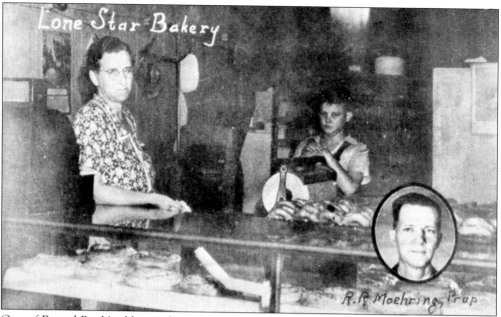

One of Round Rock's oldest and most famous businesses is the Lone Star Bakery, purveyor of Round Rock Donuts. R. R. Moehring established the business in 1926. Along with the city's broom, cheese, and lime companies, it put the town on the map. (Courtesy Round Rock Chamber of Commerce.)

The Round Rock Donut's appeal is a combination of its unique taste and color. R. R. Moehring experimented with recipes, seeking a signature product for his small-town bakery, perfecting the Round Rock Donut by the 1940s. The bakery has had five owners after Moehring, and each has passed down the special donut recipe. (Courtesy Texas Department of Transportation.)

Round Rock Jun 10 78
dr Sir
 Martin Hintze is the
Contractor word & ties in I&GNRR
Milam Leon & Jonston Counties
 respectfully
 J Rundan

When most Round Rock businesses moved from the existing settlement to the railroad town in 1876, the post office moved too, taking the "official" name on the map to the newly platted town. This postcard was mailed from Round Rock in June 1878. From 1884 to 1891, a separate post office named Old Round Rock was in operation. (Courtesy author's collection.)

Postcards were a prime and popular means of communication around the end of the 19th and into the 20th century. People also received news through local newspapers (beginning with the *Georgetown Independent* in 1853 and *Round Rock Sentinel* in 1870), telegraph (Western Union lines in 1876), and telephone (service to Georgetown and Taylor by 1884). (Courtesy author's collection.)

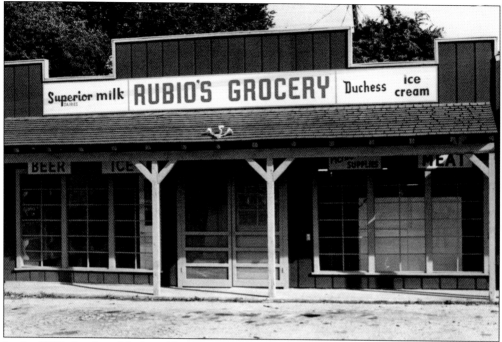

In the 1960s, brothers Mack and Lorenzo Rubio opened a grocery store in south Round Rock on Rubio Street. In 1969, Mack and his wife, Janie, opened a restaurant named Casa Rubio, and the brothers moved their grocery store downtown to west Main Street. Mack Rubio was elected the first Hispanic city councilman in 1968. (Courtesy Martin Parker.)

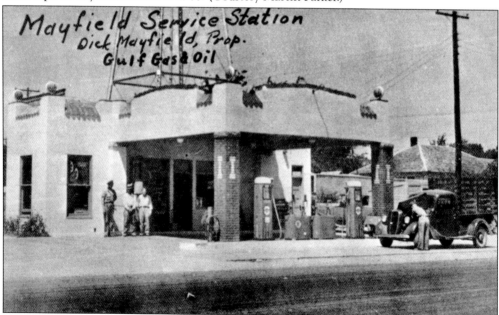

Dick Mayfield opened a Gulf filling station at the northwest corner of U.S. 81 (Mays Street) and Main Street in the 1930s. This prominent location became a popular hangout for Round Rock's "Domino Players" in the 1970s when gas rationing shut down the pump service for the day. (Courtesy Round Rock Chamber of Commerce.)

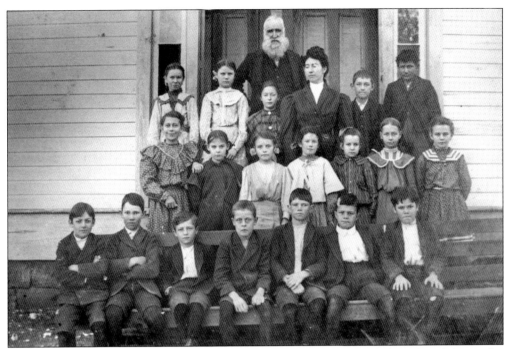

This photograph shows Round Rock High School students in 1903, including, from left to right, (first row) Robert Egger, Fritz Caswell, Bascomb Bradley, Elmer Gustafson, Carl Johnson, Reggie Royal, and unidentified; (second row) Matilda Ganzert, Wanda Dody, Mildred Johnson, Emma Johnson, Ruth Stones, Edith Pearson, and Ellen Blair; (third row) Freda Johnson, Minnie Johnson, unidentified, teacher Louise Falwell, Earl Cochran, and Paul Pokrant; (fourth row) B. T. Clinkscales, the janitor, who was also the fire builder and water drawer. (Courtesy Martin Parker.)

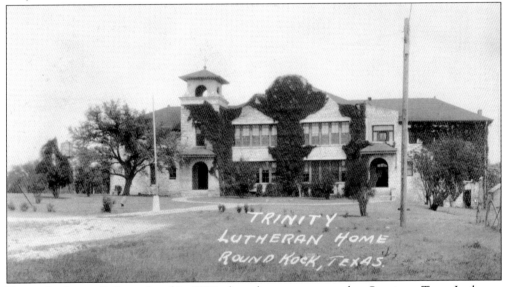

Trinity Lutheran College closed in 1929 when the campus moved to Seguin as Texas Lutheran College. The Round Rock campus continued as Trinity Lutheran Home, which cared for orphans and the aged. The site on east Main Street remained a retirement home more than a century after beginning as a college. (Courtesy author's collection.)

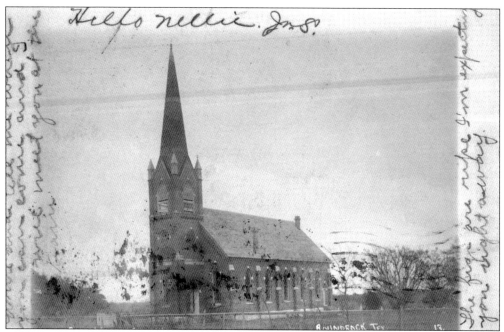

Williamson and Travis Counties became one of the main settlement areas for Texas Swedes beginning in the 1850s. Many of the Swedish immigrants who settled in Palm Valley came from the Smaland region of Sweden. They established Palm Valley Lutheran Church in 1870 and in 1894 built the Gothic Revival sanctuary that still stands today. (Courtesy author's collection.)

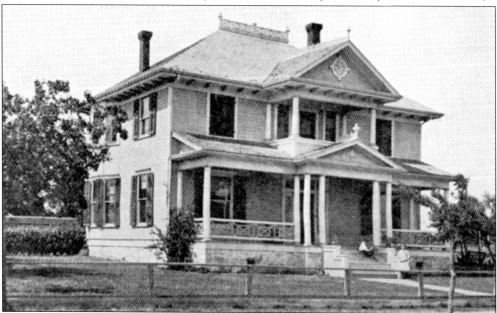

Round Rock secured the Trinity Lutheran College campus in 1905 by offering a cash bonus of $7,000, four city lots, and a water well, an offer later augmented by discount rail shipping and an additional 10 acres. Additionally, the college built a President's House one block from the campus on Main Street. The home later moved to Georgetown Street. (Courtesy Trinity College's 1919 yearbook, *The Round Rock*.)

In the 1930s, Round Rock benefited from its location on U.S. 81 as well as its diversified agricultural economy. This 1938 photograph demonstrates typical activity from commerce and tourism, even during the Great Depression. (Courtesy Round Rock Chamber of Commerce.)

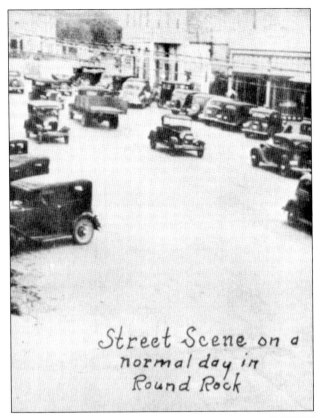

Street Scene on a normal day in Round Rock

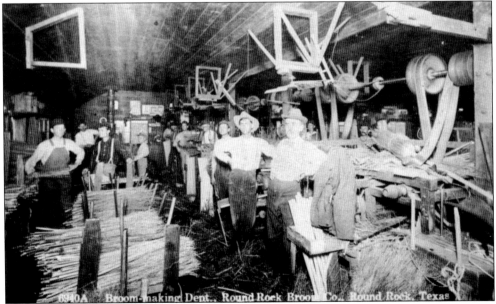

William Oatts, son of town founder Thomas Oatts, began the Round Rock Broom Factory in 1876 in Old Town. The business moved to New Town in 1900, occupying the former Harris and Taliaferro building for 11 years. The broom factory continued into the 1960s at sites near the railroad tracks and around town. (Courtesy author's collection.)

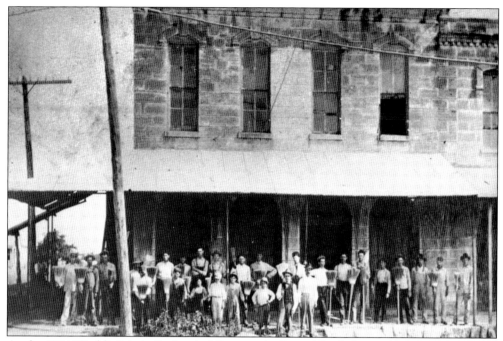

At the 1904 World's Fair in St. Louis, Missouri, the Round Rock Broom Factory was awarded a gold medal for its product. The factory then named one of its products "Gold Medal." Their advertisements stated, "A Cheap Broom is Not Good. A Good Broom is Not Cheap. Quality Never Disappoints." (Courtesy Martin Parker.)

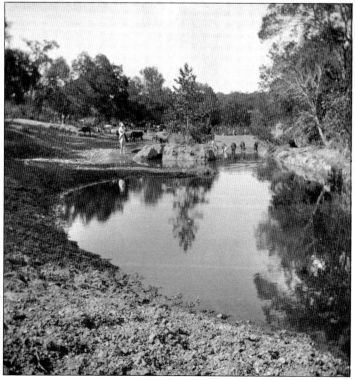

This undated photograph is captioned on the back, "Round Rock water hole, Tex." Besides offering drinking water for livestock, as shown here, ponds and creeks provided popular settings for baptisms, picnics, and recreation. The *Williamson County Sun* reported in July 1899 about Round Rock's Woodmen of the World picnic to be held at Carter Springs. (Courtesy author's collection.)

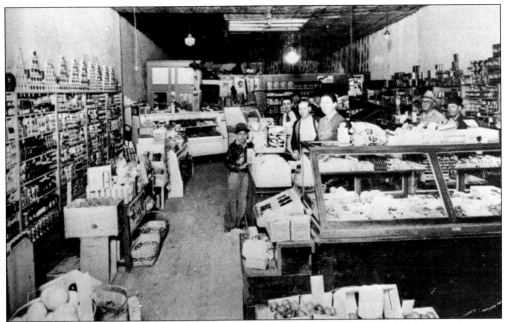

Hoyt Crimm operated a downtown grocery store in the 1920s and 1930s, first in partnership with Lex Voigt. This 1936 photograph of Crimm's Grocery on Main Street shows, from left to right, Enos Martinez, John Hester, Johnny Burk, Hoyt Crimm, Tom McNeese, and Pete Champion. (Courtesy Martin Parker.)

This 1936 photograph shows the completed U.S. 81 overpass over the International and Great Northern Railroad. Before the overpass in 1927, ten Baylor students died when a train collided with their school bus. Today Baylor University still leaves out 10 empty chairs at freshman orientations to commemorate the "Immortal Ten." (Courtesy Texas Department of Transportation.)

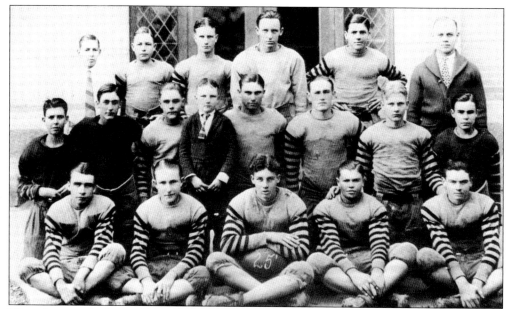

This photograph shows the Round Rock Dragons in 1925, the same year the students chose their unusual mascot. By the 1980s and 1990s, the school district experienced such rapid growth that new high schools and teams were added: the Westwood Warriors (1981), McNeil Mavericks (1992), and Stony Point Tigers (1999). (Courtesy Martin Parker.)

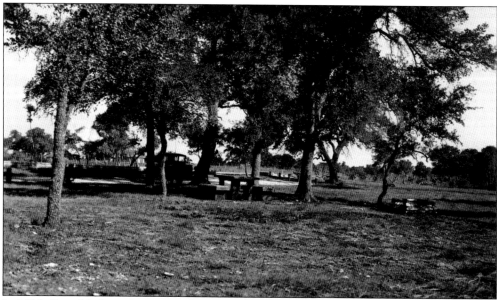

In 1934, State Highway 2 running from Laredo to Oklahoma was replaced by U.S. Highway 81 from Laredo all the way to North Dakota. In Round Rock, U.S. 81 continued north from Mays and Main Streets, replacing the State Highway 2 route that ran east along Main Street and north along Georgetown Street and what is now Farm to Market 1460. This 1936 photograph shows a rest stop along U.S. 81 north of the Round Rock city limits. (Courtesy Texas Department of Transportation.)

For 20 years, travelers to Round Rock were greeted by the "World's Largest Road Sign." Measuring 47 feet tall by 107 feet wide, the Henna Motor Company sign stood from 1938 to 1958 south of the city limits, near what is now Interstate 35 and Hester's Crossing. A 1937 Chevrolet is parked in front of the sign for size comparison. (Courtesy Martin Parker.)

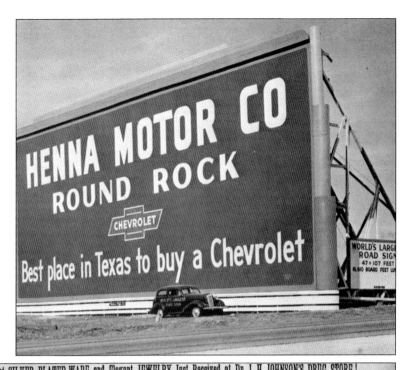

This October 22, 1886, issue of the *Round Rock News*, published by H. G. Wood, includes articles and advertisements for B. G. Grondal and H. H. Hauff, steamship agents for trips to and from Sweden; R. W. Vining, watchmaker; a meeting of the Williamson County Medical Society; and discovery of a vein of silver at the Crook place seven miles west of town. (Courtesy *Round Rock News*.)

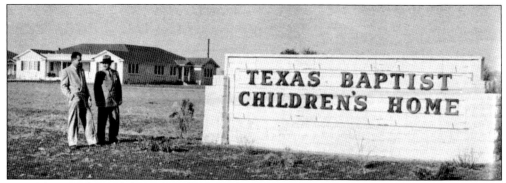

Louis Henna, who with his wife, Billie Sue, donated the land and buildings for the Texas Baptist Children's Home in 1950, stands on the campus with Dr. H. D. Dollahite (right), the home's first superintendent. Dollahite was pastor of Baptist churches in Round Rock, Marfa, and Port Arthur before coming to the TBCH. (Courtesy *Central Texas Business and Professional Directory*, William Skaggs, ed., Austin: Centex Publications, 1951.)

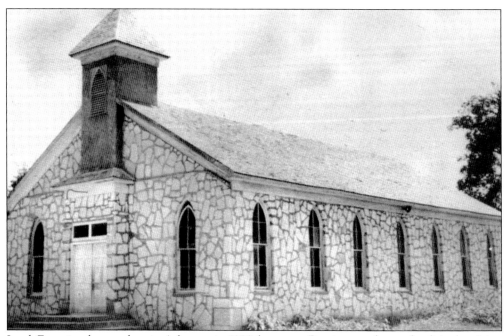

Jacob Fontaine, born a slave in Arkansas in 1808, became a Baptist preacher and political activist, founding several Baptist churches in Central Texas. Fontaine organized Good Hope Baptist Church in Round Rock in 1874 as the city's first African American congregation. Good Hope, Lake Creek, and Danville churches also offered schooling for African American students in the 1880s. This photograph shows Good Hope Church in 1965. (Courtesy Round Rock Chamber of Commerce.)

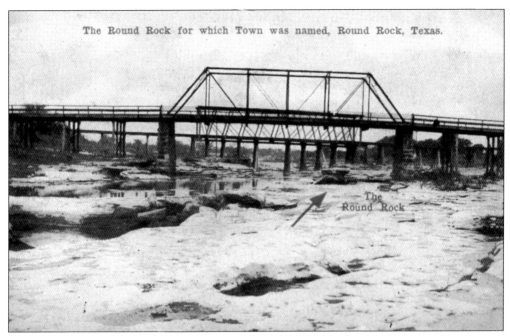

The Round Rock for which Town was named, Round Rock, Texas.

The Round Rock

This *c.* 1910 postcard shows the limestone creek bed of Brushy Creek, with the Austin-Georgetown public road bridge in the foreground and the Georgetown Railroad bridge in the background. Much of the limestone used to build commercial buildings in New Town in the 1870s and 1880s was quarried along this creek bed in Old Town. (Courtesy author's collection.)

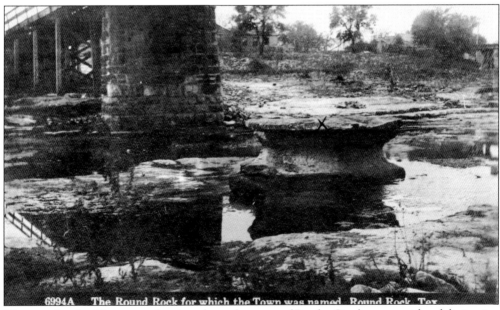

6994A The Round Rock for which the Town was named, Round Rock, Tex.

The round rock of limestone that juts above the water of Brushy Creek was considered distinctive enough to lend its descriptive name to the town. The July 1, 1965, issue of the *Round Rock Leader* reported that Tom Anderson measured the namesake rock formation at 40 feet around the top, 33 feet around the groove in the middle, 40 feet around the bottom, 11 to 12 feet in diameter, and 5 feet tall. (Courtesy author's collection.)

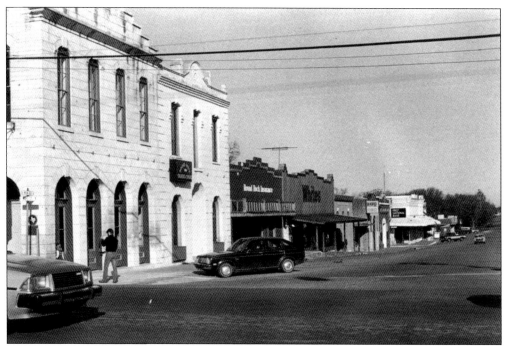

This 1982 photograph shows the north side of Main Street between Mays and Lampasas Streets. Soon after this image was taken, the entire downtown commercial district in Round Rock was listed in the National Register of Historic Places as a historic resource worthy of documentation and preservation. (Courtesy Texas Historical Commission.)

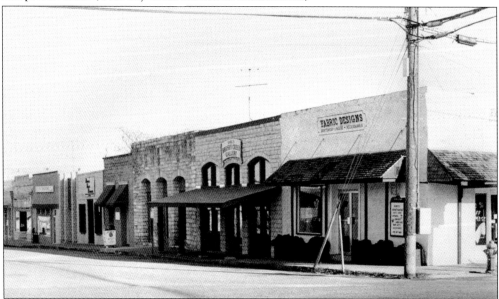

The south side of Main Street between Mays and Lampasas Streets is shown in this 1982 photograph. Besides anchoring the commercial district since the town was platted in 1876, downtown Round Rock has traditionally been the site of many community gatherings, including Daffodil Days, the El Amistad Festival, Frontier Days, homecoming parades, and Christmas Family Nights. (Courtesy Texas Historical Commission.)

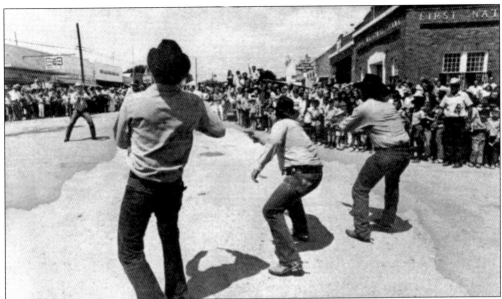

In July 1964, the Noel Grisham, Robert Griffith, N. G. ("Bunky") Whitlow, O. G. Leppin, Tom Joseph, Bennie Bustin, Virgil Rabb, Ken England, Elmer Cottrell, and Lawrence Hester families and others organized the first Frontier Days. The celebration coincided with the Old Settlers Association reunion and marked the month when Sam Bass planned to rob the Miller's Exchange Bank in 1878. Here participants reenact the Sam Bass shootout on Main Street in 1973. (Courtesy Martin Parker.)

Frontier Days has typically included a downtown parade, such as the 1970 procession shown here, food and entertainment booths, live music and dances, and historical costume contests. Other events have included the Crazy Horse Saloon, donkey baseball games, beard-growing and jalapeno-eating contests, and the chicken-flying contest, where an unsuspecting pullet was placed through the back of a regulation mailbox and encouraged to flap as far as it could when the front was opened. Reluctant fliers were often prodded with a household plunger. (Courtesy Martin Parker.)

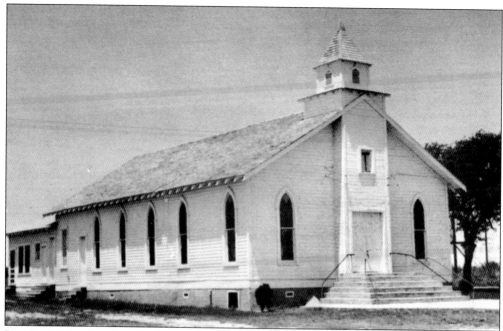

Rev. S. W. Wormley of nearby Sprinkle organized the Sweet Home Baptist Church in 1905. Mitchell Mays donated land for the first church site at what is now the southwest corner of Interstate 35 and McNeil Road. The predominantly African American congregation bought and moved a church from Hutto in the 1940s, and although the congregation has since moved, the historic sanctuary building still stands. (Courtesy Round Rock Chamber of Commerce.)

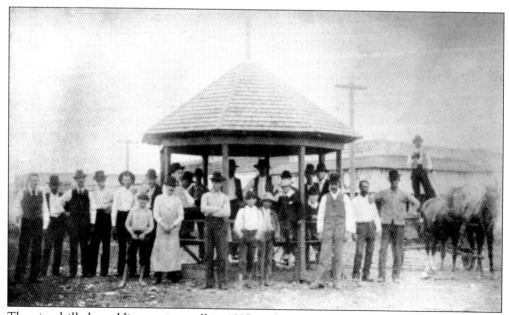

The city drilled a public artesian well in 1897 at the intersection of Main and Mays Streets, and soon after, a community gazebo was built at the site. The gazebo served as a bandstand and community gathering place. The c. 1900 gazebo was later moved to Old Settler's Park, but in 1970, a replica gazebo was built downtown. (Courtesy Round Rock Chamber of Commerce.)

Seven

THEN AND NOW

In the 1930s, Round Rock began to reflect on its past while looking toward its future. The Round Rock Cemetery Association was formed to respect the resting places of their ancestors. As Texas celebrated its centennial of independence from Mexico, concerned citizens secured historical markers honoring the pioneering efforts of Kenney's Fort and the early schools of Round Rock.

The Department of Agriculture built a series of dams along Brushy Creek for flood control and beautification in 1932. The J. C. Jackson furniture store had an art deco facade built to front their old limestone building to reflect the dynamic vitality of the age. Even as the Great Depression delivered a powerful punch to much of the country, Round Rock persevered. A *Ripley's Believe It or Not!* cartoon in the late 1930s celebrated the fact that Round Rock made it through the whole decade without a single vacant downtown business. Such businesses as the Daisy Cafe, the Alcove, and the S&S Grill kept people coming to town. The Roxy Theatre was the first permanent movie house in town and was joined by the Rock Theatre, which debuted in 1939 with the movies *Trade Winds* and *Stagecoach*, the latter being John Wayne's first big film.

Round Rock took full advantage of the help available from federal programs in the 1930s. Public works projects helped the town construct a new water and sewer system, including the downtown water tower, a new city hall, and a fire station. Meanwhile, State Highway 2 was replaced by U.S. Highway 81, built right along Mays Street, putting Round Rock on the "Main Street of America" from the border with Mexico to the border with Canada. The pieces were in place for Round Rock to thrive.

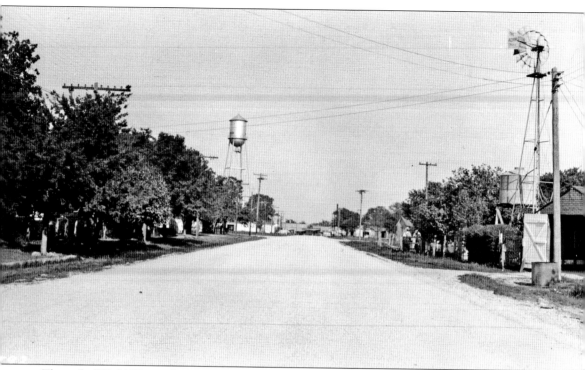

The end of World War II allowed state and local government to focus resources on new transportation and recreation facilities. The Texas Highway Department designated Ranch to Market Road (RM) 620 in 1945, extending west from Round Rock to the south shore of Lake Travis and continuing on to Bee Cave. This 1947 photograph shows the view that travelers would have approaching downtown Round Rock from the west along RM 620. The city water tower, built in 1938, is visible on the left, while a barn and windmill are shown on the right of the photograph. (Courtesy Texas Department of Transportation.)

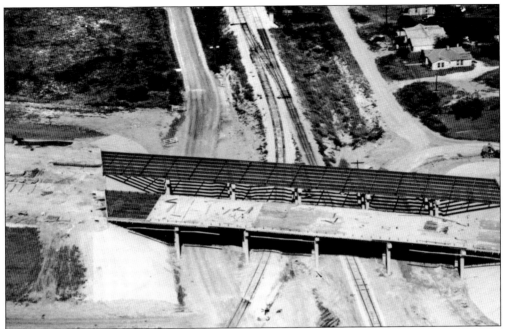

Construction of Interstate 35 came to Round Rock in the late 1950s. This photograph shows a bridge being built over McNeil Road and the junction of the Georgetown Railroad and Missouri Pacific Railroad (formerly International and Great Northern) tracks. When this bridge was later widened, the grooves beneath the decking became home to a large urban bat colony. (Courtesy Texas Department of Transportation.)

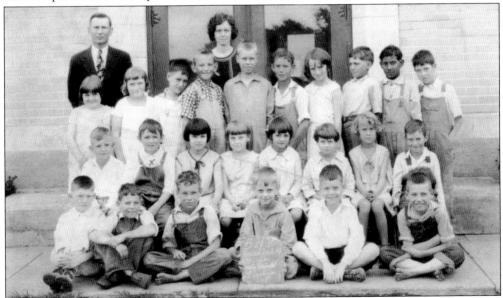

Round Rock High School's second-grade class of 1930–1931 is pictured here. Citizens voted to create an independent school district in 1913, and as the Round Rock Independent School District's centennial approached, the growing district oversaw 4 high schools, 9 middle schools, 30 elementary schools, and more than 40,000 students, with more campuses on the way. (Courtesy author's collection.)

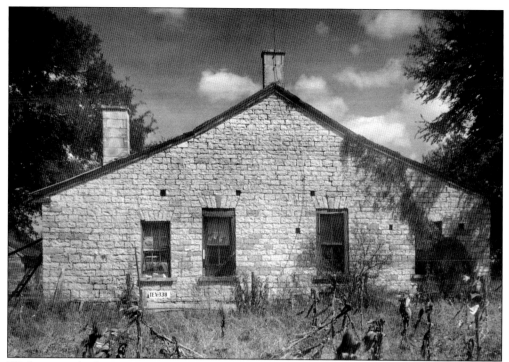

Washington Anderson, a veteran of the Battle of San Jacinto, was an early settler and one of Williamson County's first commissioners in 1848. The Andersons lived in log houses until building this large stone house on the north shore of Brushy Creek in 1859. The homestead also included a separate slave quarters. (Courtesy Library of Congress.)

This 1850s envelope includes one of the first mentions of the name Round Rock, with a letter sent to Chappell Hill near Brenham. Several early community institutions, including the post office, the Masonic Lodge, and the First Baptist Church, all date from the 1850s. (Courtesy author's collection.)

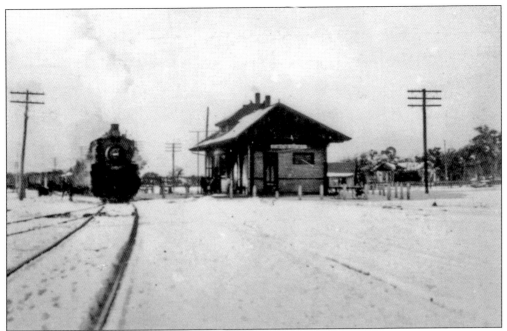

This 1922 photograph depicts the depot during a rare snowfall. The train is a 2-8-2 oil-burning locomotive headed north from Austin. Around the dawn of the 20th century, two Missouri Pacific trains arrived each morning, and two International and Great Northern trains arrived each evening. (Courtesy Martin Parker.)

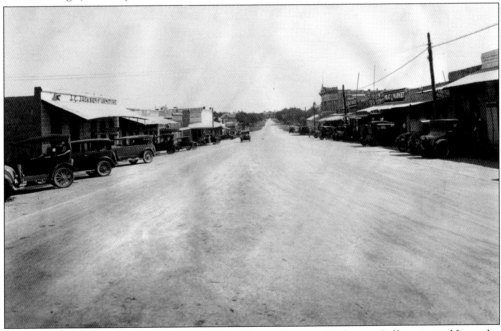

This 1929 photograph looks east down Main Street. Trinity Lutheran College is visible at the end of the street at top center. J. C. Jackson's furniture store can be seen on the left, two years before Jackson installed an art deco–style facade. Several of the businesses have tin awnings. (Courtesy author's collection.)

In 2003, a city work crew was demolishing a house near the floodplain of Brushy Creek when the bulldozer revealed a pioneer log cabin hiding beneath more modern siding. When the old logs were found, demolition was halted. This construction style and the house's location in Old Town point to this building being one of the oldest in Round Rock. (Courtesy author's collection.)

This photograph of the rear of the rediscovered pioneer log cabin in Old Town shows an exterior chimney and a cistern made of limestone. After the pioneer construction was discovered, the city made plans to stabilize and preserve the historic structure. (Courtesy author's collection.)

This photograph shows the 1878 Masonic Lodge and post office building when it was just over a century old. Members of Masonic Lodge No. 227, Ancient Free and Accepted Masons, built this handsome Italianate-style edifice when they moved their lodge from Old Town to New Town. The post office occupied the first floor, while the Masonic Lodge and other groups met on the second floor. (Courtesy Texas Historical Commission.)

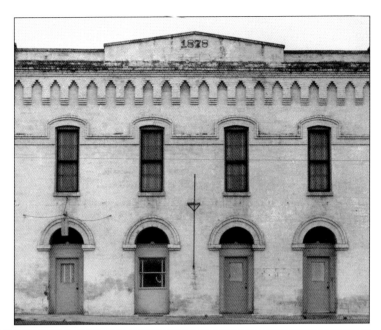

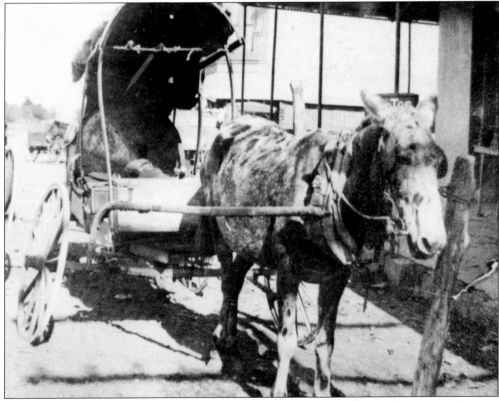

This undated photograph shows a horse-drawn buggy tied to a wooden hitching post in front of a downtown business. In a September 1912 election in precinct 23 (unincorporated Round Rock) to determine whether "horses, mules, jacks, jennets and cattle shall be permitted to run at large," the vote was 77 for and 40 against the resolution. (Courtesy Martin Parker.)

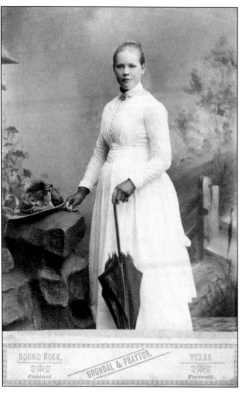

This *c.* 1890 photograph captures the image of an unidentified woman in the studio of B. G. Grondal and William B. Praytor. Swedish native Bror Gustaf Grondal came to America at the age of 14, living in Minneapolis, Minnesota, before coming to Round Rock. There he met and married Sarah Noyd, and together they had a flourishing photography business. The Grondals moved to Lindsborg, Kansas, and B. G. practiced photography there until the age of 90. (Courtesy author's collection.)

The Jacob Harrell family was one of the first to permanently settle in Round Rock, having already been among the first families living in Austin when it was declared the capital of the Republic of Texas in 1839. Jacob was elected mayor of Austin in 1847, but the following year, the family moved to Round Rock. Their family cemetery, near Bowman Road and Interstate 35, received an official Texas Historical Marker in 1999. (Courtesy Texas Historical Commission.)

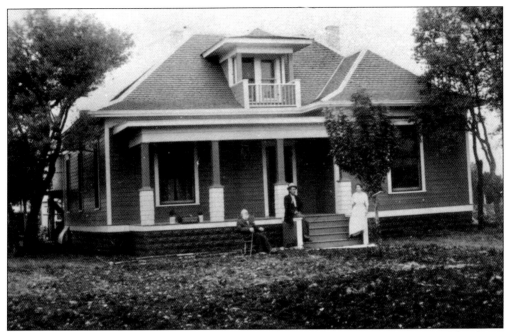

This *c.* 1910 photograph shows an unidentified house in Round Rock. Lumber and hardware companies, notably the J. A. Nelson Hardware Company, were responsible for the construction of the majority of the city's houses in the early 20th century. Many of these homes were built from catalog plans and replaced the more vernacular, rectangular-plan cabins and houses of the prior generation. (Courtesy Martin Parker.)

This photograph printed in the *Round Rock Leader* shows the Round Rock Cheese Factory on a busy day in the summer of 1928. The cheese factory was the first successful such venture in Texas, and within two years, Armour and Swift of Fort Worth bought the factory, giving it stability and backing that would keep the factory in operation until the late 1960s. The *Leader*, which normally printed one four-page newspaper each week, celebrated the sale with a special 24-page edition highlighting Round Rock businesses. (Courtesy *Round Rock Leader.*)

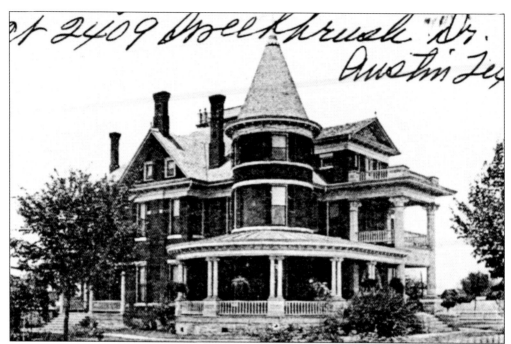

Page Brothers architects of Austin designed this house for the Andrew and Hedwig Nelson family. Construction began in 1895, the year that Andrew died, and continued until 1900. The opulent Queen Anne–style home, clad in red brick, was a prominent landmark on Main Street just east of the commercial district. (Courtesy *Lloyds Magazine*, 1928, issue unknown, in files at Round Rock Public Library.)

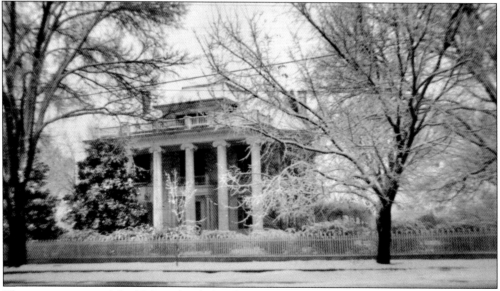

Three generations of the Nelson family lived in the house on Main Street. Thomas E. Nelson commissioned Dallas architect Wilson McClure to alter the original Queen Anne–style architecture to Classical Revival style in 1931. This undated photograph shows the dramatically changed house in a snowfall. The house was designated a Recorded Texas Historic Landmark in 1973. (Courtesy Texas Historical Commission.)

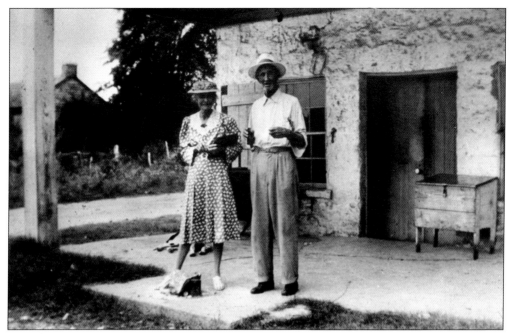

This photograph of the historic Thomas Oatts store in Old Town is dated around 1930. Kentucky-native Oatts was Round Rock's first postmaster from May 1851 to June 1860, and he built this combination house, store, and post office in 1853. He also accompanied his son-in-law on cattle drives to Nebraska in 1871 and 1883. (Courtesy Texas Historical Commission.)

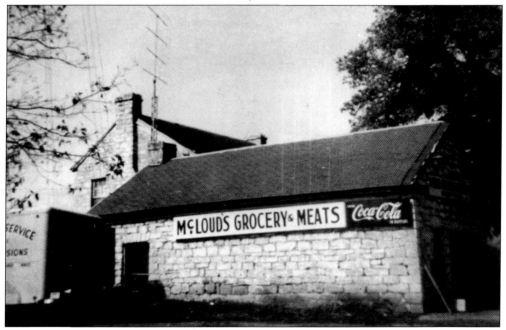

This *c.* 1955 photograph shows the Thomas Oatts store at 100 years of age, now serving as A. E. and Lela McCloud's grocery store. In 1982–1983, Oatts's store was designated a Recorded Texas Historic Landmark and was listed in the National Register of Historic Places. (Courtesy Texas Historical Commission.)

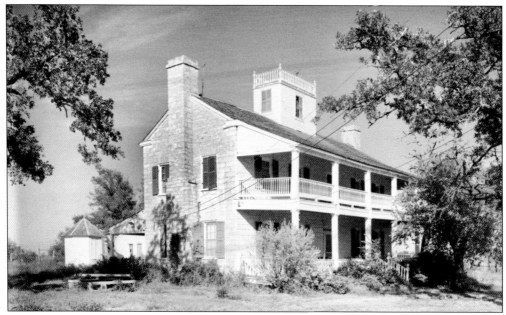

Capt. Nelson Merrell, born in Connecticut in 1810, was one of Round Rock's earliest settlers. He moved to Kenney's Fort, established near Brushy Creek by the Dr. Thomas Kenney family, in 1839. Merrell later lived between Round Rock and Austin, and established Merrelltown, which is marked today only by a cemetery. In 1870, Merrell hired French stonemason Antria Smith to build his family a home on what is now U.S. 79 on Round Rock's east side. In 1970, the house was listed in the National Register of Historic Places. (Courtesy Library of Congress.)

This photograph shows Interstate 35, with two lanes in each direction, running north from Round Rock in 1970. The highway rest area, recently built, is visible at the top left of the photograph. Since removed, it was on the west side of the highway across from the later Round Rock Premium Outlets. (Courtesy Texas Department of Transportation.)

In January 1927, ten students and athletes from Baylor University were killed when an eastbound train collided with their bus in Round Rock. In 1935, the Texas Highway Department built an overpass at the crash site at Mays Street and the railroad tracks. They installed this memorial plaque on the bridge to honor the "Immortal Ten." (Courtesy Texas Department of Transportation.)

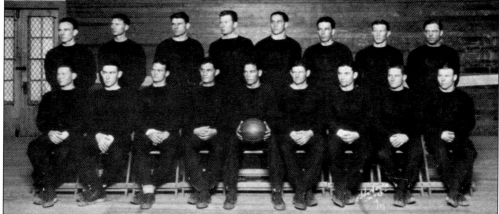

From left to right, members of the 1927 Baylor basketball team are (first row) ? Murray (manager), ? Winchester, ? Dillow, Keifer Strickland, Louis Slade (captain), ? Walker, ? Hannah, ? Kelley, and Weir Washam; (second row) Ira Dryden, Fred Acree Jr., John R. Kane, Cecil S. Bean, ? Hailey, R. Shelton Gillam, J. Gordon Barry, and Ralph Wolf (coach). Baylor basketball players James Clyde Kelley of Waco, Sam Dillow of Fort Worth, James Stephen Walker of Gatesville, Robert L. Hannah of Waco, William Penn Winchester of Waco, and Robert R. Hailey of Lott, manager Willis Edwin Murray of Gatesville, scorer Jack Castellaw of Ennis, yell leader Merle Dudley of Abilene, and student sportswriter Ivey R. Foster Jr. of Taylor lost their lives in Round Rock on January 22, 1927. (Courtesy the 1927 *Round-Up* of Baylor University.)

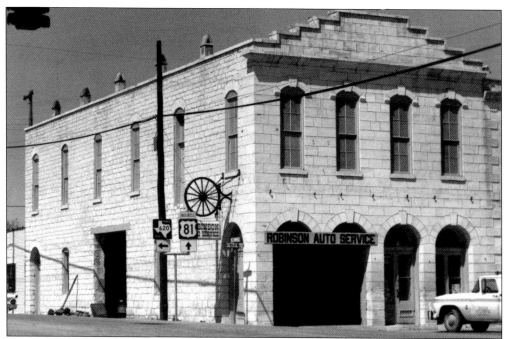

The Harris and Taliaferro building, dating from 1880, became most associated with the Round Rock Broom Factory, which was housed here from 1900 to 1911. The Italianate-style structure is an ashlar-cut limestone load-bearing masonry building with a stepped parapet and keystone arches. (Courtesy Texas Historical Commission.)

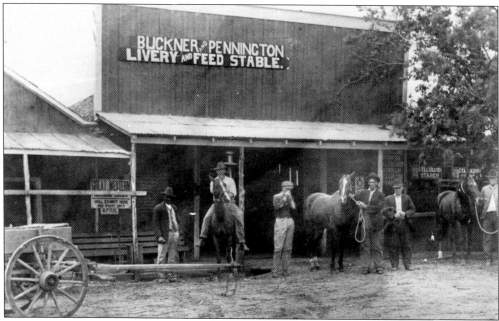

The Buckner and Pennington Livery and Feed Stable, formerly owned by W. J. Fouse, is shown in this 1916 photograph. The business was in the 100 block of West Main Street. Shown from left to right are unidentified, Bud Parks, Dewey Long, Marshall Ferrell, Claude Buckner Sr., and Dud Pennington. (Courtesy Martin Parker.)

L. O. RAMSEY, PROP. ● HIGHWAY 81 ● ROUND ROCK, TEXAS

L. O. Ramsey built the Rock Courts, pictured here, on U.S. 81. Tourist courts, like this one and Lane Courts (later Adams Courts), also built on U.S. 81, capitalized on the increased popularity of the automobile and improved road conditions that made recreational travel possible. (Courtesy author's collection.)

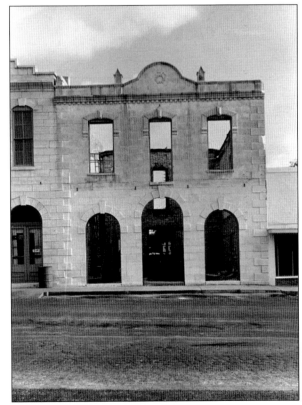

The Otto Reinke building, one of the oldest in New Town, dates from 1879. Reinke was a confectioner and baker. The building was later Dr. Alexander McDonald's drugstore, a lodge meeting hall, a tin shop, and a pool hall. In 1963, fire gutted the interior, and University of Texas architect Martin Kermacy directed the restoration of the building. (Courtesy Texas Historical Commission.)

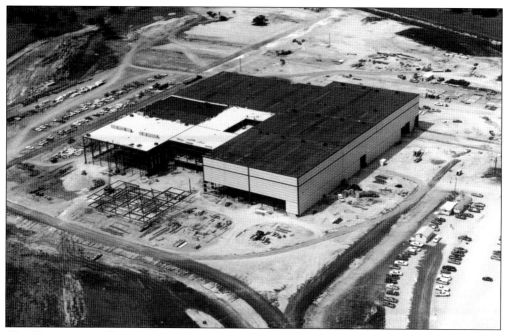

The Westinghouse Electric Corporation built a new Gas Turbine Systems Plant in Round Rock in 1972, ushering in a new wave of industrial and technological businesses that diversified the city economy and contributed to the rapid population growth of the city and schools. The plant was built on 200 acres along Interstate 35 and was designed to employ more than 700 people at full operation. (Courtesy Martin Parker.)

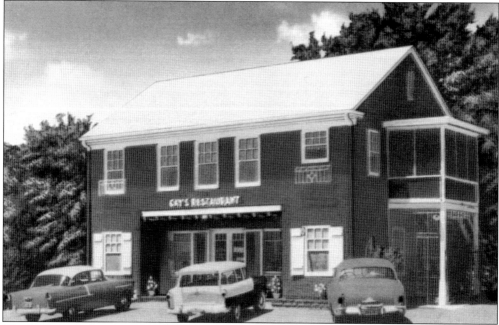

The S&S Grill changed hands and names as different restaurants for 20 years, including Gay's Restaurant, shown in this c. 1950 postcard. Later businesses have included Brook Mays Music and Beyond the Red Door. (Courtesy author's collection.)

August B. Palm worked with S. M. Swenson to bring several hundred young Swedish immigrants to Central Texas in the 1860s and 1870s. Palm was also the postmaster at Round Rock from October 1876 to September 1880. In this May 1880 letter to his wife, Adela, August laments, "I wrote you I had to stay in the office Sunday, much to my disappointment. Much love, your affectionate husband, A. B. Palm." (Courtesy Irene Varan.)

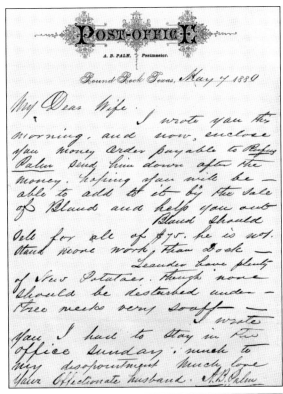

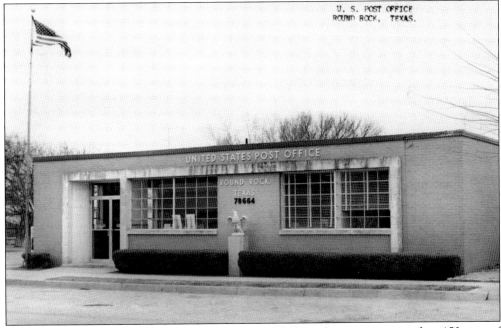

The Round Rock Post Office has been housed in four different locations in more than 150 years of existence. The first location was in Thomas Oatts's store in Old Town, followed by the first floor of the 1878 Masonic Lodge in New Town. The facility pictured here was built in 1960 and served as the post office until it moved back to Old Town in 1984. (Courtesy author's collection.)

Louisiana-native Dr. Joseph A. Holloway (1852–1915) had a practice in Round Rock in the 1900s and 1910s. He and his wife, Annie, had four children: Hallie, Lizzie, Robert, and Archie. In this letter dated Christmas Day 1905, Dr. Holloway corresponds with a friend in Childress. "Your letter came this a.m., which was quite a Xmas treat to me," Dr. Holloway writes. "All the children are at home except Hallie. . . . Robert will remain about 2 weeks and then go back to St. Louis. He is getting along nicely with his dental course. . . . Archie is not doing anything. He would not go to school and I don't know what to do with him. . . . Lizzie spends the most of her time with Hallie. Sister is in good health and so is my wife. I weigh nearly 200 #s [pounds]." Dr. Holloway is buried at the Round Rock Cemetery. (Courtesy author's collection.)

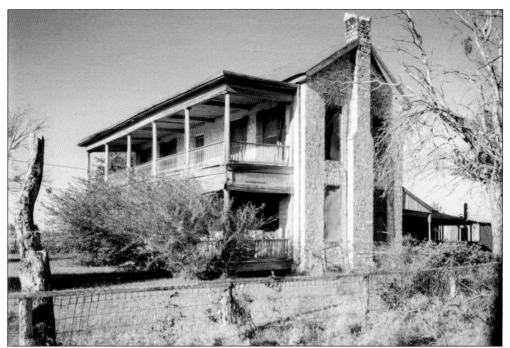

Round Rock is fortunate to have surviving examples of pioneer construction from the 1850s. One building that did not survive is pictured here in 1961. Known as the Dr. G. T. Cole house, it was built about 1873 in Old Town but was razed in the 1980s. (Courtesy Library of Congress.)

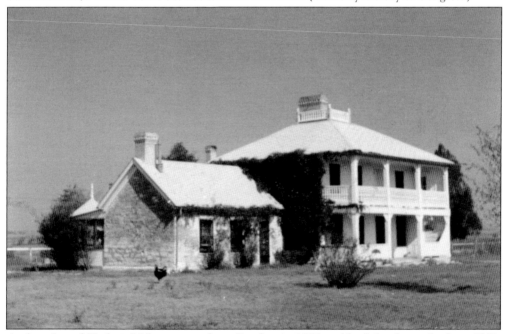

Andrew J. and Hedwig Nelson came from Sweden in 1854 and had this house built in 1860. Tradition has it that Swedish masons built the house in exchange for passage across the Atlantic Ocean. The house was designated a Recorded Texas Historic Landmark in 1965. (Courtesy Texas Historical Commission.)

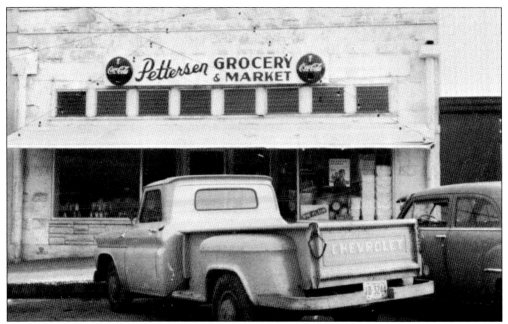

Rudolph Pettersen operated a grocery store at 117 East Main Street from 1946 to 1971. This photograph shows the store as it appeared in 1968. (Courtesy Round Rock High School.)

Don and Betty Hester opened the Dairy Kreme at 409 Round Rock Avenue in the 1960s. This 1968 photograph includes menu items like sundaes for 15¢ to 25¢, malts for 30¢, and orange drinks or purple cows for 25¢. (Courtesy Round Rock High School.)

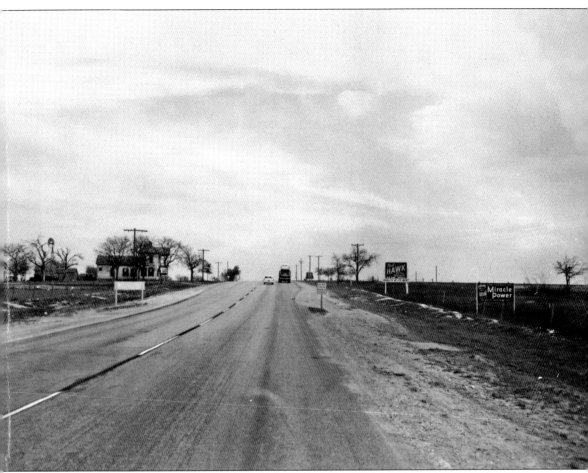

This 1950s view of U.S. 81 shows the road leading south out of Round Rock on the way to Austin. The road is one lane in each direction on an undivided highway, with a "creeper lane" southbound for a passing zone. This landscape of rural farms and wooden advertising signs was forever changed when Interstate 35 was built through Round Rock and Austin in the late 1950s. The interstate facilitated the development of suburbs, and within a generation, Austin was growing to meet Round Rock, now the second largest city in Central Texas. The combination of good roads, good schools, and good people meant that the community was primed to prosper. In a matter of a few years, the community has gone from rural, to suburban, to urban living. Round Rock continues to travel a road toward its future beyond the next rise. (Courtesy Texas Department of Transportation.)